SISTER AND I
from Victoria to London

EMILY CARR

ROYAL BC MUSEUM
Victoria, Canada

Published by the Royal BC Museum,
675 Belleville Street, Victoria, British Columbia,
V8W 9W2, Canada.

Design by Chris Tyrrell, RBCM.
Editing (Introduction and Glossary), layout and
 typesetting (Scala) by Gerry Truscott, RBCM.
Digital production by Kim Martin and Carlo
 Mocellin, RBCM, and by Reber Creative.
Printed in Canada by Friesens.

Library and Archives Canada Cataloguing in Publication

Carr, Emily, 1871–1945
 Sister and I from Victoria to London / Emily Carr ;
 introduction by Kathryn Bridge.

ISBN 978-0-7726-6342-9

 1. Carr, Emily, 1871–1945 – Travel – Canada. 2. Carr,
Emily, 1871–1945 – Diaries. 3. Carr, Emily, 1871–1945 –
Notebooks, sketchbooks, etc. 4. Canada – Description
and travel. I. Royal BC Museum II. Title.

FC74.C37 2011 917.104'56 C2011-901041-0

About the Royal BC Museum

British Columbia is a big land with a unique history.
As the province's museum and archives, the Royal
BC Museum captures British Columbia's story and
shares it with the world. It does so by collecting,
preserving and interpreting millions of artifacts,
specimens and documents of provincial significance,
and by producing publications, exhibitions and
public programs that bring the past to life in exciting,
innovative and personal ways. The RBCM helps to
explain what it means to be British Columbian and to
define the role this province plays in the world.

The Royal BC Museum administers a unique
cultural precinct in the heart of British Columbia's
capital city. This site incorporates the Royal BC
Museum (est. 1886), the BC Archives (est. 1894), the
Netherlands Centennial Carillon, Helmcken House,
St Ann's Schoolhouse and Thunderbird Park, which
is home to Wawaditła (Mungo Martin House).

Although its buildings are located in Victoria,
the Royal BC Museum has a mandate to serve
all citizens of the province, wherever they live. It
meets this mandate by: conducting and supporting
field research; lending artifacts, specimens and
documents to other institutions; publishing books
like this one; producing travelling exhibitions;
delivering a variety of services by phone, fax, mail
and e-mail; and providing a vast array of information
on its website about all of its collections and
holdings.

From its inception 125 years ago, the Royal
BC Museum has been led by people who care
passionately about this province and work to fulfil
its mission to preserve and share the story of British
Columbia.

Find out more about the Royal BC Museum at
www.royalbcmuseum.bc.ca.

Contents

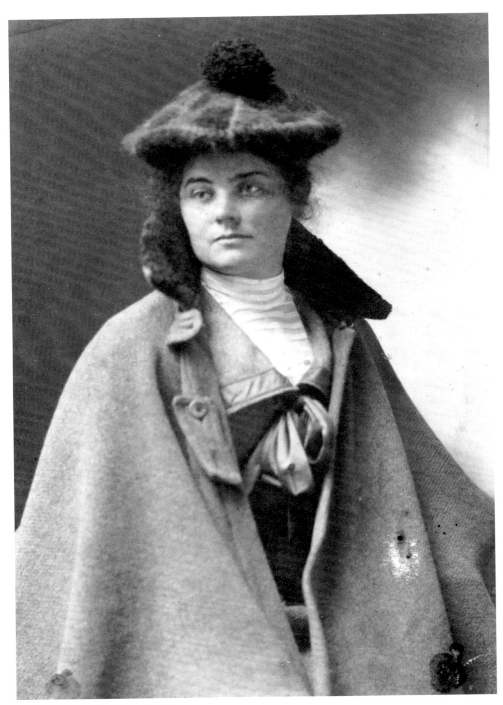

Emily Carr while in England in 1901.
John Douglas photograph; BC Archives I-60891.

Foreword
A Gem in a Steamer Trunk

Kathryn Bridge

Emily Carr holds a unique dual designation in our Canadian cultural consciousness. She is equally famous as an artist and an author. Her stories, published in several books, have become as much a part of the heritage of her home province, British Columbia, as her paintings and sketches of First Nations monumental art, forest interiors and landscapes.

In 1941, just a few years before her death, Emily Carr won the Governor General's Award for non-fiction for *Klee Wyck*, her first book, in which she recalls her travels to First Nations villages and the people she met. This stunning literary debut would be followed by other auto-biographical offerings, each covering different stages of her life. Writing as an occupation came late in life to Carr, a woman who had always defined herself as an artist and whose watercolours and oil paintings placed her in the forefront of the Canadian art movement. She switched her creative output as her physical health deteriorated, preventing her from going out on sketching trips and exerting herself before a large canvas. Writing became a satisfying alternative – she could now paint pictures with words.

Emily Carr died in 1945 at age 73, with her affairs in order. She had set aside paintings for a trust collection for the people of British Columbia; she cleaned house; she organized her possessions. Many of her most precious documents and remembrances she placed into a well-used wooden steamer trunk, the same piece of luggage that she had taken to San Francisco, Alaska, England and France (the journey described, in part, in this book). She closed the lid and affixed a handwritten label, "To Ira".

Carr's friend, Ira Dilworth, was also her editor and executor. When he opened the lid of the steamer trunk he found inside a literary and artistic treasure – many of Carr's drawings from her days in art school, her sketchbooks, journals and diaries, many hundreds of letters received, and typewritten drafts of her stories. A note placed on top conveyed her instructions.

She asked Dilworth to be trustee of her literary legacy and continue to publish her work after her death. Carr had already seen her first three books published. After *Klee Wyck* came *The Book of Small* (1942) and *The House of All Sorts* (1944). But more lay written and awaiting posthumous publication in the steamer trunk. Dilworth obliged by carefully editing her manuscripts and then submitting them to a publisher. In 1946 *Growing Pains* came to light, and in 1953 *The Heart of a Peacock* and *Pause: A Sketchbook* were published – all three from the material Carr had set aside in the trunk.

Dilworth began to prepare her journals, but died in 1962 before he completed the task. These would eventually be published in 1966 under the title, *Hundreds and Thousands*. After Dilworth's death, the contents of Carr's trunk

5

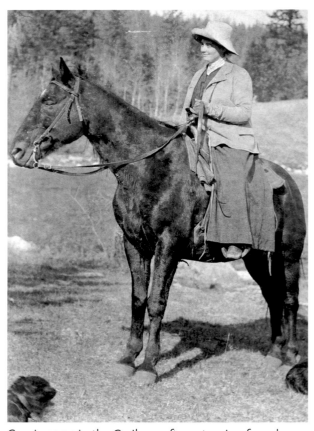

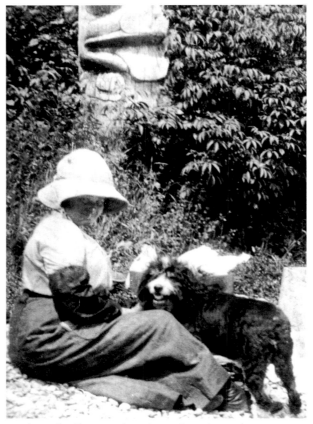

Carr in 1904 in the Cariboo, after returning from her first trip to England. Archibald Murchie photograph; BC Archives I-51569.

Emily and Billie on a beach at Cha'atl, Haida Gwaii, in 1912. William Russ photograph; BC Archives F-07756 (detail).

were split between his heirs. In 1985 and 1989, the trunk (and most of its contents) came to the BC Archives in Victoria where it remains. This material provides invaluable documentation of Emily Carr's life and thoughts. Historians, artists, literary scholars and others delve into this material on a regular basis as they research different aspects of Emily Carr.

The trunk's contents have proven fruitful for several publications, including Doris Shadbolt's *Seven Journeys: The Sketchbooks of Emily Carr.* Susan Crean's careful rereading of Carr's journals resulted in *Opposite Contraries,* which restored more than 40,000 words edited out of *Hundreds and Thousands.* A selection from more than 400 letters between Carr and Dilworth was published in *Corresponding Influence* by Linda Morra. Most of Carr's yet unpublished stories came out

in *This and That.* But the trunk held yet a few more gems. *Sister and I from Victoria to London* is one of them. And most of the supporting documentation included here – the postcards, the descriptions of France in her manuscripts and the photographs of Carr herself – also lay among the contents of her old steamer trunk.

Sister and I from Victoria to London

Emily Carr created this 92-page illustrated journal in 1910 as a "funny book" to amuse both herself and her sister, Alice. This first edition of *Sister and I* has been reproduced as a complete facsimile, with high-resolution scans of the original. Carr used a standard exercise book, its

pages framed by borders of single and double red lines. Here, the original pages are shown in full, the worn, much handled edges visible, set as they are on slightly larger pages.

This was not Carr's first "funny book". She employed the same format in an earlier vacation journal, in 1907, when she and Alice headed north on a steamer to Juneau and Skagway, Alaska. In this journal she also wrote on the left-hand pages and painted watercolour illustrations on the right-hand pages. Unfortunately, all that remains of her "Alaska Journal" are black-and-white photographs of six pages. The original, last seen in the 1950s, has vanished.

Sister and I captures through visual caricature and whimsical prose the travel adventures Emily and Alice, aged 38 and 40, from the time they left their home in Victoria on July 11, 1910, to their arrival in London, England, almost two months later. They took their time crossing

Canada on a Canadian Pacific Railway train. The sisters had a reservation on the ship leaving Quebec City, but had allowed extra days to break up the train journey and explore. They made several stops en-route, left the train and spent nights in hotels. After their 19-day train journey to Quebec City, they waited for 12 days for an ocean liner to take them to Great Britain. On August 12 they boarded the *Empress of Ireland* for a week's voyage across the Atlantic to Liverpool. Then the sisters travelled again by train to London, where the journal ends.

Emily chronicles not the scenery of Canada as it whizzes by their railcar window, but the theft of a bag of peaches as they slept, antics in sleeping berths and the wonders that unfolded in the small towns that they stopped at to break up their journey. In Quebec City she devotes pages to the saga of an unfortunate shopping purchase, and later, on board ship, to the misery

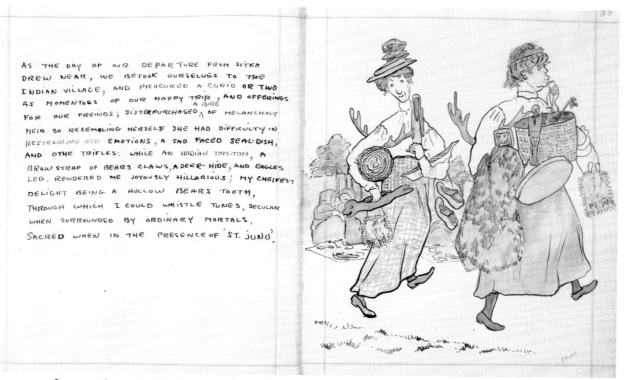

Two pages from Emily Carr's "Alaska Journal". Only six pages survive, and only as black-and-white photographs. BC Archives I-67766.

Mt. Burgess, Emerald Lake. near Field, B.C.

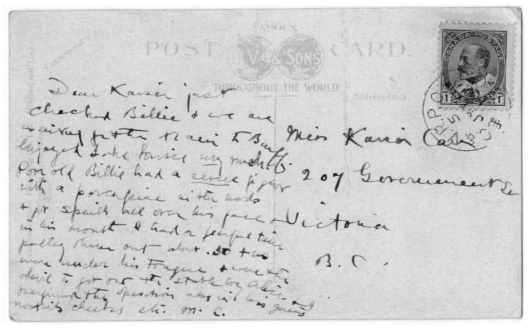

POST CARD.
V. & SONS
THROUGHOUT THE WORLD
Address Only

Dear Kaiser just
checked Billie & we are
waiting for the train to Banff
Enjoyed Lake Louise very much!!
Poor old Billie had a scrap (figure)
with a porcupine in the woods
& got spikes all over his face
in his mouth & had a perfectly
polly skin out — about 50 + no
more under his tongue & was the
devil to get out the stable boy & his
during the operation also with his gums
nostrils cheeks etc. M. C.

Miss Karen (Carr)
207 Government St
Victoria
B. C.

Postcards sent home by the sisters from Field, BC,
and Medicine Hat, Alberta. They addressed these
cards to their eldest sister, Edith, whom Emily had
nicknamed "Kaiser". Emily's card, above, describes
Billie's misadventure in Lake Louise – see pages 28–31.

SOUTH RAILWAY ST., MEDICINE HAT, ALTA.

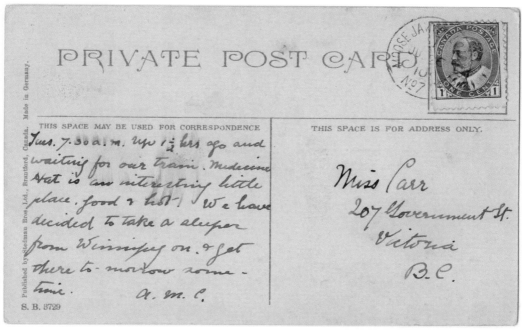

PRIVATE POST CARD

THIS SPACE MAY BE USED FOR CORRESPONDENCE

Published by Stedman Bros. Ltd., Brantford, Canada. Made in Germany.

Tues. 7.30 a.m. Up 1½ hrs ago and waiting for our train. Medicine Hat is an interesting little place. Good & hot— We have decided to take a sleeper from Winnipeg on. & get there to-morrow some-time.
α. m. C.

S. B. 3729

THIS SPACE IS FOR ADDRESS ONLY.

Miss Carr
207 Government St.
Victoria
B.C.

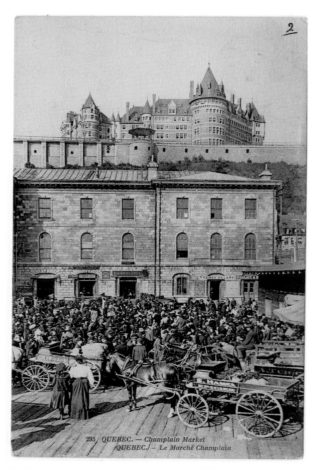

295 QUEBEC. — Champlain Market
QUEBEC. — Le Marché Champlain

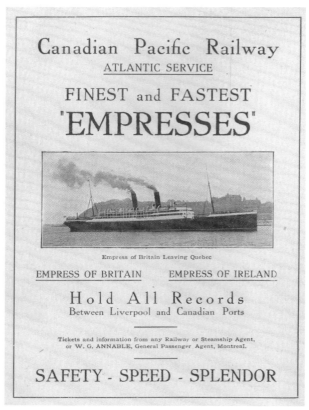

An ad for Canadian Pacific's Empress class liners. Built in 1905, the *Empress of Ireland* was more than 170 metres long and accommodated over 1500 passengers. But this steamship had a short history.

On May 29, 1914, the *Empress of Ireland* sank after being struck by a freighter on the St Lawrence River. Over 1000 people went down with the ship, making this accident the deadliest maritime disaster in Canadian history.

On the reverse side of this postcard from Quebec City, Alice wrote: "The Chateau Frontenac is in the Upper Town, the Market in Lower. You can go from one to the other by the elevator, or by a combination of hilly streets & steps, or by a half hour's ride round in a tram."

of seasickness. But in true Emily fashion, she makes fun of her errors and sickness, devoting several pages to her desperate attempts, with fellow vertigo-sufferers on board the *Empress of Ireland*, to find a remedy.

Emily drew herself as a plump matronly figure often with a red face and puffy cheeks and Alice as a neat beanpole whose face was dominated by an overly long nose. Emily made these caricatures intentionally comical, just as she did in the "Alaska Journal". In fact, Emily and Alice look to have aged very little in the three years between journals.

In *Sister and I*, Emily and Alice laugh and cry, adjust to the other's foibles, survive their adventures and journey as a team, emerging with their umbrellas intact, until almost the end.

Carr printed her story in capital letters, writing in black ink and making corrections as necessary. She tried, but not hard, to keep her lines straight. The story unfolds in true Emily fashion, complete with misspellings (mistaken and intentional) and words of her own invention. A glossary (pages 108–109) attempts to clarify or translate Carr's more difficult words and define some of the words more commonly understood

in 1910 than today; it also describes some of the less widely known places she mentions.

The journal ends with the Carr sisters' arrival in England, where after a brave rescue of lost luggage, they missed the train connection. But all was not lost for Emily, because the waiting time provided the perfect excuse for her to buy a parrot.

Why the Long Journey?

Sister and I does not tell readers why Emily and Alice Carr travelled to Great Britain. London, after all, was not their final destination. After a few days of rest and orientation at a guest house where Emily had stayed years before on her first trip to England, the sisters took another sea voyage across the channel to France. Alice went simply to enjoy a vacation, having taken a year's leave of absence from teaching at her private school. But for Emily, the journey meant so much more. She was following her dream. "Everyone said Paris was the top of art," she reminisced later in *Growing Pains*, "and I wanted to get the best teaching I knew."

To better understand *Sister and I* and to place it in the context of Carr's life some biographical background is necessary. Carr had attended art schools in San Francisco from 1891 to 1893, in England from 1899 to 1904 (albeit with time lost due to illnesses) and in France from 1910 to 1911 (again with illnesses). Biographers Maria Tippett and Paula Blanchard have called Carr's decision in 1899 to study at the Westminster School of Art in London unfortunate, because that school was a little old fashioned in its approach to art. A school in Paris might have been a better choice for someone wanting to know the very latest in art trends. But her decision to study in England probably had a very practical underpinning. England was the birthplace of both her parents. It was safe and acceptable. Carr had family and friends living in England, and had been given written introductions to friends of friends. She also followed the example of her Victoria friends

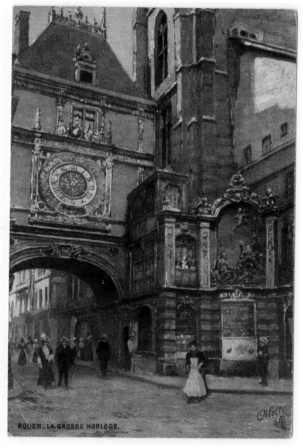

Alice sent this postcard from Rouen, northwest of Paris, on May 16, 1911.

and fellow aspiring artists, Sophie Pemberton and Theresa Wylde, who just a few years earlier had travelled to England for their art. To attempt France as a first overseas destination would have been a much bolder decision, but one that ignored her own social precedents. And, undoubtedly, her inability to speak French (and, it seems, an unwillingness to learn) also factored in her decision.

Carr was aware of the art scene beyond England. But the aesthetic tastes of her friends, combined with visits to the Royal Academy, and her own art studies struck a pedestrian chord. It was all a little too conservative. Some of her fellow students talked of art they had seen, had news of French art and ideas that seemed bigger and more expressive. Carr wrote in *Growing*

Pains: "I was beginning to feel that Paris and Rome were probably greater centres for Art than London.... I sort of wished I had chosen to study in Paris rather than in London."

What has been assumed until now, because of the lack of evidence, was that Carr remained in England from 1899 to 1904 and did not make any attempt to expose herself to the more modern art trends practiced on the continent. Carr certainly left no clues in her trunk or in her stories. But a recently discovered letter she wrote while in England to Mary Cridge in Victoria provides new evidence that Carr travelled to Paris in 1901.

> Did I tell you I went to Paris at Easter time it was so delightful there I went with Miss Livingstone you remember she was in Victoria for a while. We were there 12 days the picture galleries were my great delight they are delightful & it is such a pretty city too. I went to the Louvre every day it was delightful to see the very pictures you had heard of & dreamt of half your life. I wondered if I would wake up & find it was a dream.*

Carr stayed in Paris for 12 days. She wrote that she visited the Louvre many times, but also talked about other "picture galleries". Although it is not possible to know for certain, Carr might have sought out exhibitions of modern art, or of post-impressionist painters. In 1901, Easter day was April 7. If Carr arrived in Paris in the last few days of March she would have been able to attend the large Van Gogh tribute exhibition at the Galerie Bernheim-Jeune. It would be this exhibition that posthumously propelled Van Gogh's art to fame. In April, the Salon des Indépendants opened to include works by Monet, Pissarro, Matisse, Cezanne, Marchel Duchamp and Vlaminck. At the very least, she had to have

spent many days exploring the French capital.

Perhaps she intended to return to Paris later, but life got in the way. Alice arrived in England in June and stayed until the fall. By this time Emily had already started showing symptoms of ill health and her doctor advised her to try art school away from London. She and Alice went by train to Cornwall where she enrolled at St Ives. By 1902, breaking studies to return to London, she fell seriously ill, eliminating any chance of further travel.

Nevertheless, the brief experience she had of Paris in the spring of 1901 – and maybe it was only a frisson, an awareness of something big, grander and more powerful than she had seen previously – combined with remembrance of satisfactory health while there, stayed in her mind. She resolved that she would go to Paris for her next serious foray into formal art studies.

Once home in Canada, it did not take long for her to realize that the tentative artistic breakthroughs that she secured while in England were important. She was hopeful she would be successful in her goal of rendering the west coast landscape in a way that was her own. Her drawing masters had complimented the successes as she strived to capture the movement in the woods. They had shown her that there was the sunlight in the shadows. But it was not enough. Still, she remained unconvinced of her technique, her ability to do justice to the Canadian landscape. She wondered at the "bigger, broader seeing" claimed in Paris. Perhaps she kept in mind images from 1901, of galleries in Paris, of the excitement experienced on that trip.

In *Growing Pains*, she wrote: "I wanted now to find out what this "New Art" was all about. I heard it ridiculed, praised, liked, hated. Something in it stirred me but I could not at first

* Letter from Emily Carr to Mary Cridge, May 7, 1901. City of Victoria Archives, PR76, box 26, b2, f4.

Mary Cridge was the mother of Nellie, Emily's best friend. The Cridges lived across the street from the Carr family home.

The Miss Livingstone Carr mentions visited Victoria in the spring of 1898 to conduct a series of

lectures and demonstrations of modern cooking, sponsored by the local Council of Women. Several articles in the *Daily Colonist* newspaper both advertise and describe these events, attended by many Victorians including the Carrs and their friends. Research is ongoing to learn more about Miss Livingstone.

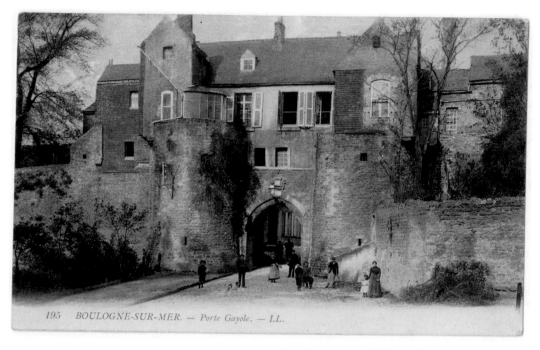

195 BOULOGNE-SUR-MER. — Porte Gayole. — LL.

Another postcard from Alice in France to sister Edith in Victoria. See the back pages for more postcards.

make head or tail of what it was all about. I saw at once that it made recent conservative painting look flavourless, little, unconvincing." She made plans and saved her money to go to Paris again. Alice began taking French lessons, for she planned to go with Emily. In just over nine years since her brief visit to Paris, Emily Carr would return to embrace the modern thinking and to be changed. Complacency was out of the question.

Carr's autobiographical writings in *Growing Pains* provide a full account of her time in France, so we know she moved from city to countryside, worked under several teachers and, again, suffered bouts of disabling illness, which Carr in later years rationalized as her continuing reaction to living in large cities. But this writing is retrospective, written much later in life. Very little documentation from her actual time in France survives. Fortunately, both Emily and Alice sent postcards, as they had during the Canada leg of the journey, home to their sisters. Several of these postcards are included here. Of

course, they're intended only as quick reports, passing on only the bare essentials.

But one letter has recently surfaced that dates from Carr's last year in France when she studied in Brittany under English-born, modern artist Harry Gibb. The letter to her close friend, Nellie Laundy (nee Cridge) describes the place and the people she encountered while painting *en plein aire*:

> Britany is delightful. I love the peasants they are so sly & sort of melancholy. The kids creep up to you in the woods like young deer. The cow herders are the raggedest little things we are great chums, meeting on this mutual ground of grins. But it serves very well for a language. I have what I call my studio on a hill behind the hotel there is a charming wood. I am there now with my lunch & having a Sabbath rest writing letters & reading a home paper. This is a sea side spot with a splendid stretch of sand tho it is <u>hot</u> but you have to wade nearly up to the English coast before there is enough water to swim in it. It is

13

Alice was still with her when Emily sent this card home on July 12, 1911.

Alice has already left me & started on her homeward way. She is in Scotland at present sails this week. I feel very desolate when I remember I'm all alone in this frog eating foreign jabbering country. My French is awful & I don't give a whoop. I can't be bothered to learn & I just hit or miss any word that happens to be any where near the one I want. It's even worse here for the Bretons speak an entirely different language from the French so my few words are mostly out of use though they understand French (tho not mine) at the hotel.

Although Carr mined France for what it could provide for her art, she made little or no effort to understand its people or speak its language. Instead, she relied on friendly smiles and gestures, as she had when visiting First Nations villages in BC.

In November 1911, Carr returned to Victoria. The work she had accomplished in France, the new techniques learned, the experience of having two paintings accepted by the Société du Salon d'Automne for their exhibition at the Grand Palais des Champs Elysées in Paris* and her memories of the people she met in so many different situations – all provided her with inspiration to last the rest of her life. She came back with a "new way of seeing" and an understanding of a much wider world of ideas, of acceptances of bold shapes, bright colours, abstracted forms, and swirling discourses of art shared.

This trip to France transformed Carr and her art: she was now truly international in experience, reference and association. She left behind the comical figure that she drew of herself in Sister and I. France gave her a confidence that she would need to survive, for the road to artistic acceptance in her home country would be long and lonely. But she faced her future with courage. She travelled to remote coastal villages, finding the inspiration and subject matter for her art, undertaking a lifetime's commitment to painting her beloved west coast and its people.

excellent for children quite safe.... We are having fearfully hot weather evidently unusual for here as they all gasp & moan so over it.*

Carr's letter reflects the intimacy in *Sister and I*. For these are her thoughts at the time, not remembrances tempered by her awareness of the larger audience likely to read her book. Carr's opinion on the French language and culture is transparent and honest. She reveals an ethnocentric prejudice common to those of English ancestry, and is oblivious to cultures and customs beyond those of her own society. She continues in the same letter:

* Letter from Emily Carr to Nellie Laundy, July 10, 1911. City of Victoria Archives.

* Edythe Hembroff-Schleicher, *Emily Carr: The Untold Story*, Hancock House, 1978. p. 367

SISTER AND I FROM VICTORIA TO LONDON.

MEMOIRS OF ODS AND ENDS.

Victoria B.C. July 11th 1910

The harrowing wrench of the last partings
is over : with red eyes and a body guard
of sniffing 'faithfuls' attending us, we start
on our long planned trip abroad,——
"A tear or two and a sniff or so
the whistle blows and away we go"——
When the last tear bedewed kerchief has
faded into oblivion. We pull ourselves
together with the firm determination of
extracting all the pleasure and profit
possible from our travels.

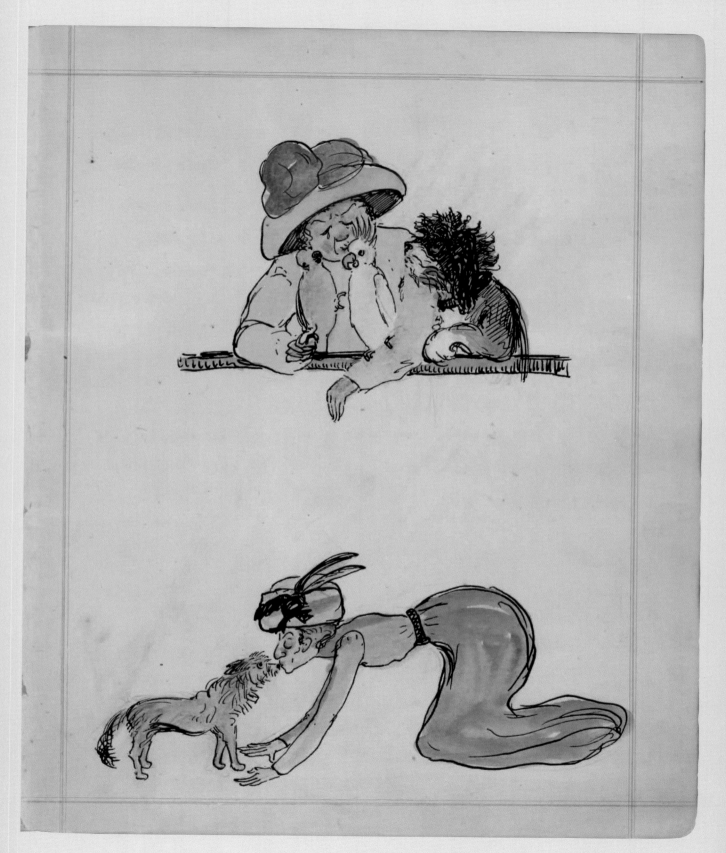

JULY 12th. WE CHANGE AT VANCOUVER FOR THE TRAIN; AND SPEND A LONG WEARISOME AND UNEVENTFUL DAY, SPEEDING EAST ARRIVING AT SICAMOUS JUNCTION AT 11.30, I ATTEND TO THE HOUSING OF BILLY-DOG, WHILE SISTER ENGAGES THE ROOM AT THE HOTEL SHE IS ALREADY HALF ASLEEP WHEN I JOIN HER BUT MURMERS "HITCH ON YOUR POCKET SHURE" THESE STOUT POCKETS, ARE RECEPTICLES WHEREIN TO KEEP OUR VALUABLES WHILE TRAVELLING; THEY ARE TO BE WORN NIGHT AND DAY, AND ARE THE PARTING GIFTS OF TENDER FREINDS; BETHINKING ME TWERE WISE, TO PREPARE FOR NEXT DAYS COMFORT, BY TAKING AN ANTI-TRAINSICK PILL; I POISE IT ON MY TONGEU-TIP, AND AM JUST IN THE ACT OF RAISING MY COL-LAPSIBLE CUP FULL OF WATER TOMY LIPS TO WASH IT DOWN WHEN——

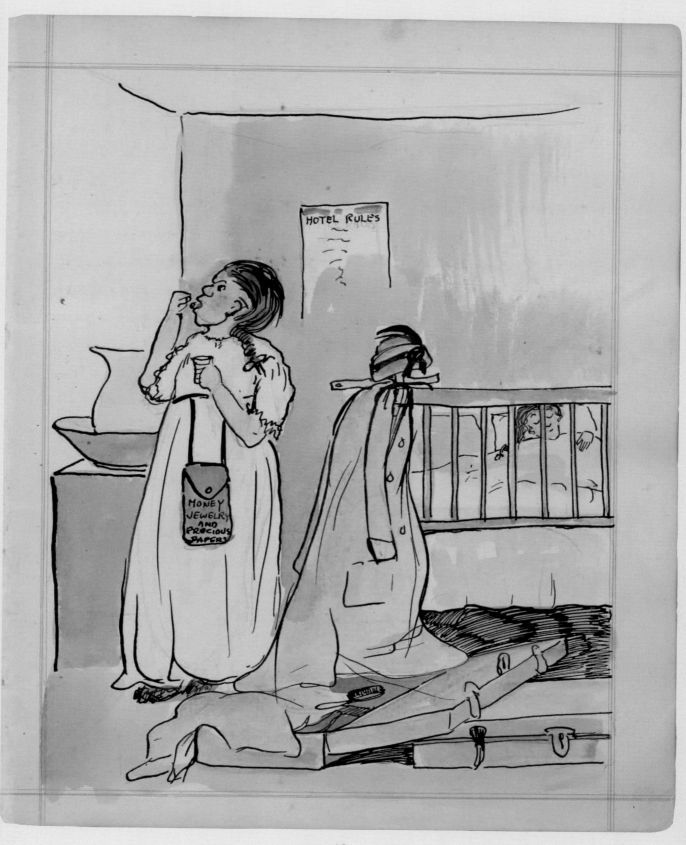

WITH A THUNDROUS CRASH, AND A BLINDING DUST, DOWN FELL THE ENTIRE CEILING ON MY INNOCENT HEAD: OF COURSE THE PILL WENT THE WRONG WAY; AND THE COLLAPSIBLE CUP COLLAPSED; DOING SERIOUS DAMAGE TO THE PRECIOUS POCKET. AND CONTENTS; SISTER AROSE FROM HER PILLOW WITH A GLAZED WILD STARE: CHOKING, BLINDED GASPING, I RUSHED FOR THE BELL TO FIND IT BROKEN; I WAS FOR RUSHING TO THE OFICE; BUT SISTER PLEADED THAT MY ATTAIR WAS UN-BEFITTING FOR PUBLICITY, AND BESAUGHT ME TO LET THE MATTER REST UNTILL THE MORNING; IF THE MATTER RESTED WE DID NOT: WE ROSE EARLY, AND MOUNTING THE PILE OF DEBRIS, WE DUG OUT OUR LIME FILLED SUIT CASES, BEING OF A VINDICTIVE NATURE, I PUT ON MY BIGGEST BOOTS AND GROUND THE PLASTER WELL IN TO THEIR CARPET: WHILE GENTLE SISTER WENT BARE FOOT LEST SHE BEGRIME HER SOCKS.

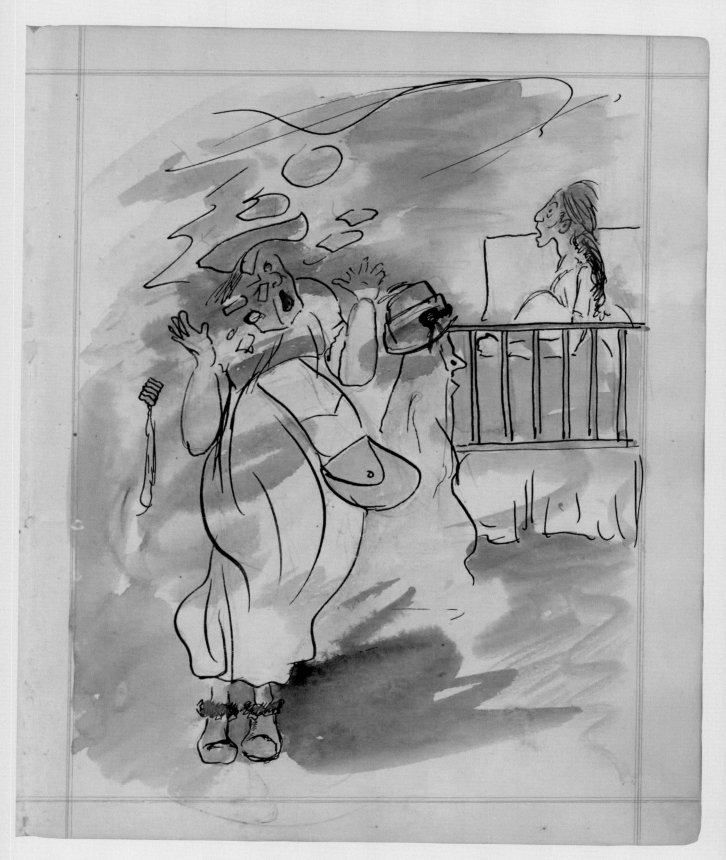

I TACKLED THE MANAGER MYSELF, KNOWING
HOW VELVET SOFT SISTER WOULD LET HIM DOWN,
IN FACT I HAD THE NIGHT WATCHMAN, STILL
ON DUTY, GO UP AND EXTRACT HIM FROM HIS
BED, HE APPEARED DOUR AND SURLEY, BUT IN
ABOUT FIFTEEN MINUTUS, WE BOARDED OUR TRAIN
LEAVING A VERY MEEK AND WILTED MANAGER
AND WITH A RECEIPTED BILL IN OUR POCKETS
THAT HAD IN NO WISE LIGHTENED OUR PURSES.

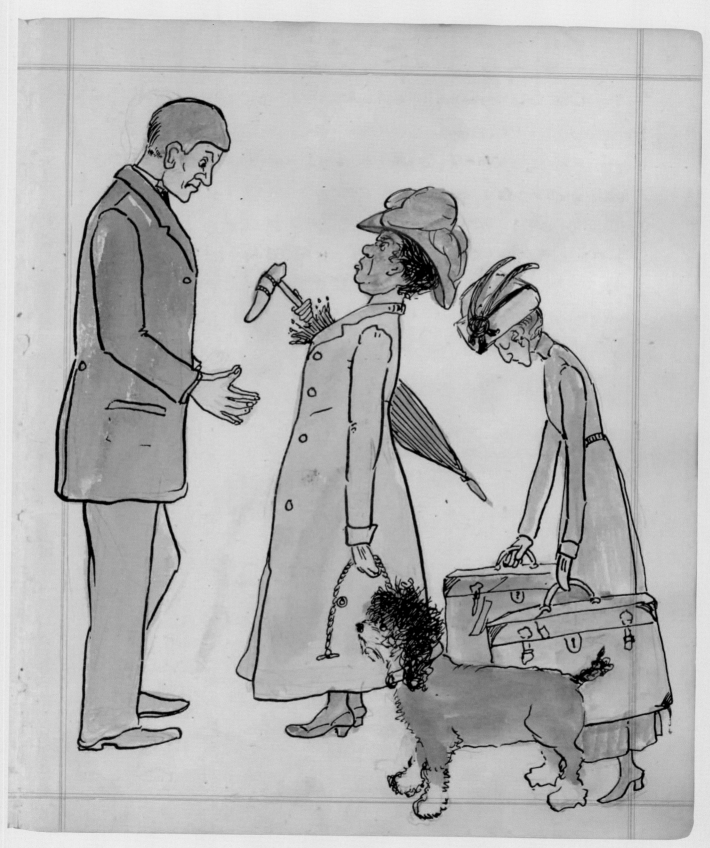

JULY 14: ANOTHER LONG DAY OF TRAIN
TRAVEL AND WE ARRIVE AT GLACIER HOUSE:
IT IS GLORIOUSLY COOL AND BEAUTIFUL!
WE CLIMB UP THE MOUNTAIN PATH TO THE
GLACIER. BILLIE TOWING ME UP THE ENTIRE
WAY AND GLAD TO DO IT. WE OFFER SISTER
A TOW BUT SHE SCORNFULLY REFUSES
VEIW MAGNIFICENT: HEAT INTENSE.

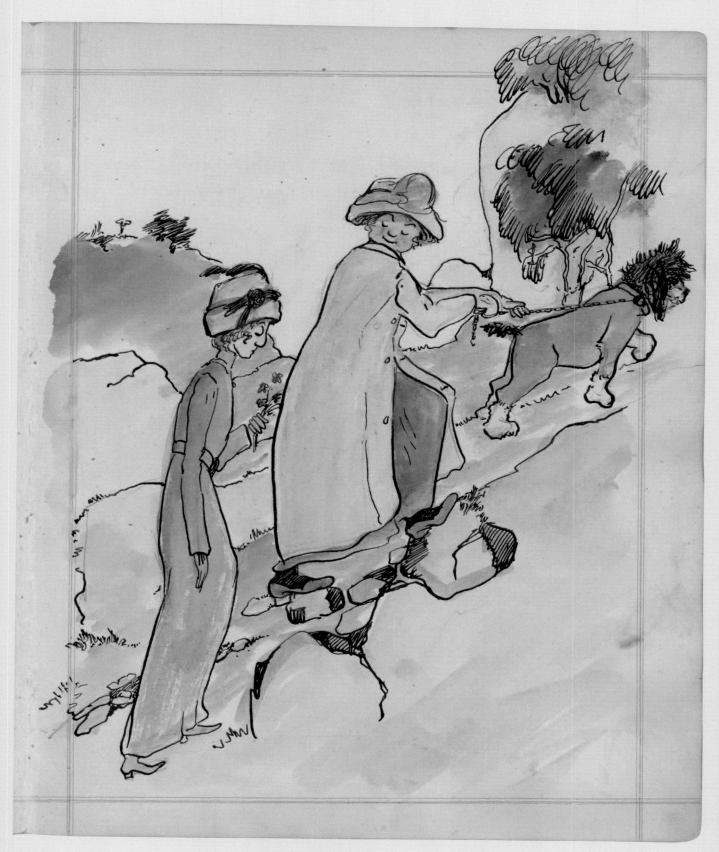

ARRIVING AT THE GLACIER: WE HAUL OURSELVES OVER THE SLIPPERY SURFACE, UP INTO THE ICE CAVE, BY A ROPE FIXED IN THE GLACIER FOR THE PURPOSE, THE CAVE IS 60 FEET DEEP, AND SUPERB IN COLOURING: THE WATER TRICKLES FROM THE CEILING, AND HOLDING OUR LITTLE CUP, WE DRINK 'PREHISTORIC FLUID, WHICH HAS SUCH EFFECT UPON US, THAT WE CEASE TO FRET UPON THE ANTIQUE CUT OF OUR GARMENTS. CARING NOT THAT WE HAVE NEITHER 'UMBRELLA' HATS NOR 'HOBBLE' SKIRTS. WHICH ARE AT PRESENT IN VOGUE.

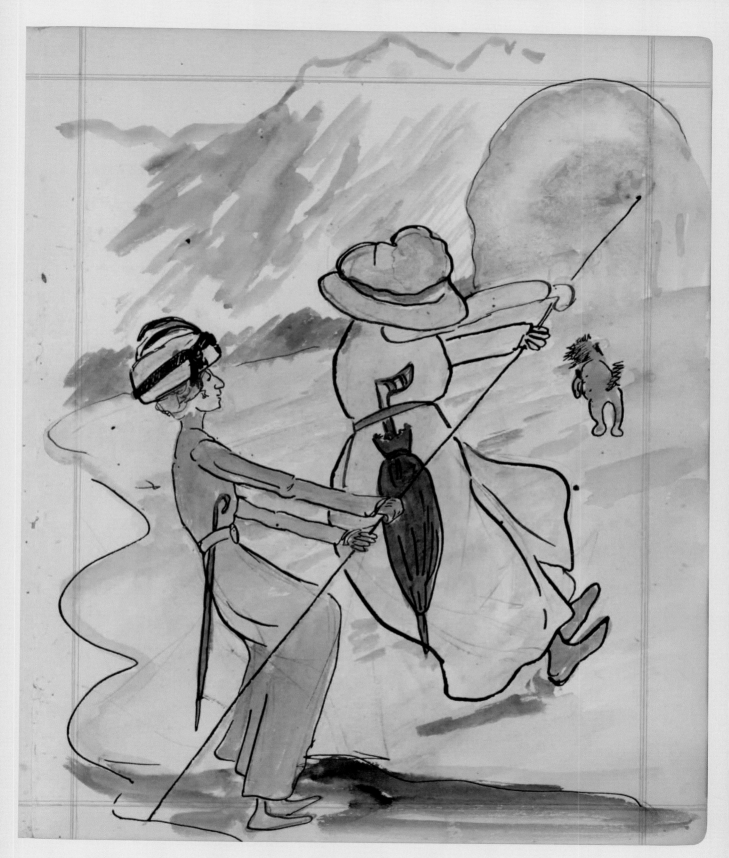

LAKE LOUISE JULY 15.

LOUISE IS HEAVENLY! YET JUST TO RE-
MIND YOU, THAT YOU STILL INHABIT THIS THORNY
EARTH, THE MOSQUITOES ARE A TORMENT,
BILLIE WHO IS VERY ELATED AT THE PRIVILEDGE
PERMITTED HIM IN THIS HOTEL. OF SLEEPING UNDER
MY BED; ON A NOSEING EXPIDITION INTO THE
FOREST ENCOUNTERS A PORCUPINE, THE
BATTLE WAS A FEIRCE ONE, AND WE ARRIVE
ON THE SCENE IN TIME TO FIND BILLIE,
WITH COURAGE STILL UNDAUNTED WHIMPERING
PITIFULLY WITH PAIN AND BAFLED RAGE, AND
AND RESEMBLING A HUGE PINCUSHION; WE HAD
MUCH ADO EXTRACTING THE QUILLS. WHICH WERE
INSIDE HIS MOUTH AS WELL AS OUT: THE
SYMPATHY OF THE ENTIRE HOTEL IS EXTENDED TO
HIM. BUT NO SOONER HAS HE RECOVERED
HIS SPIRITS THAN._____

28

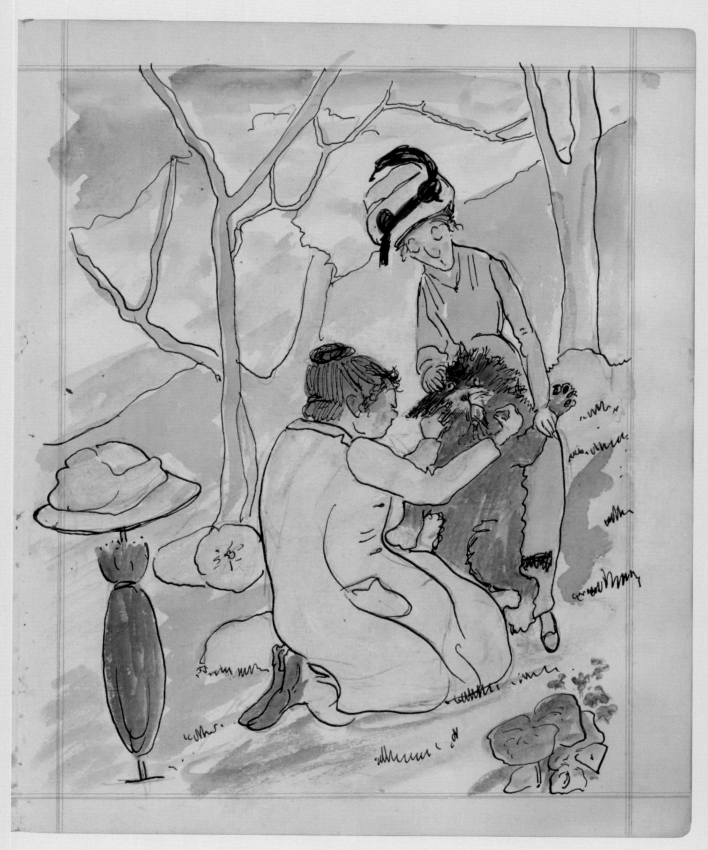

HE SEATS HIMSELF UPON A WASPS NEST!
WHERAT, WE ALL MAKE A WILD DASH FOR
HOME; AND RAIN BEGINS TO FALL IN TORRENTS
SO WE SPEND AN UNEVENTFUL AFTERNOON
IN DOORS.

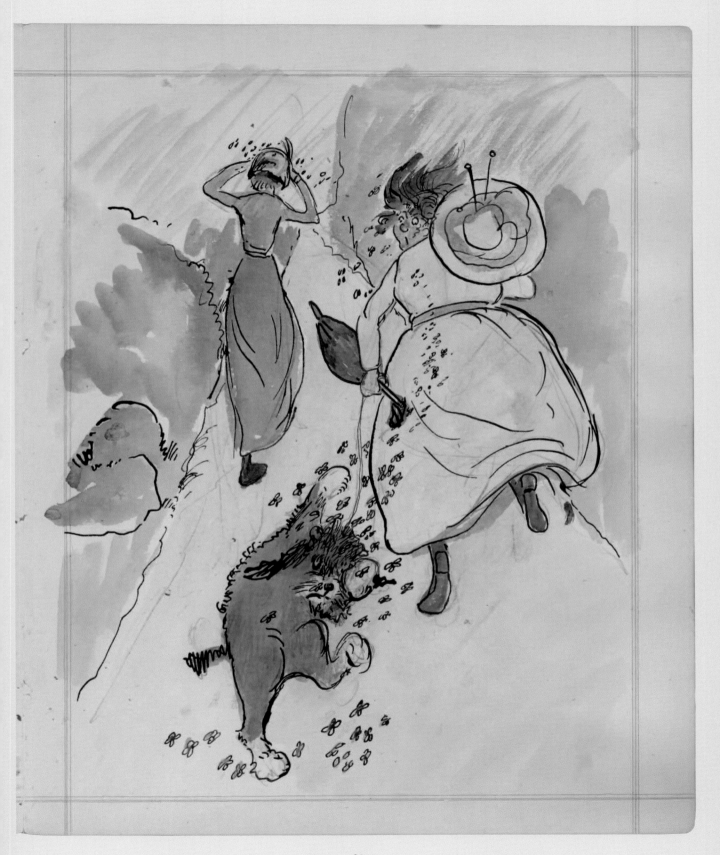

WITH MUCH PLEASURE WE DISCOVER AN ARTIST FRIEND IN THE HOTEL AND THE EVENING IS PLEASANTLY PASSED IN THE DISCUSSION OF SKETCHES.

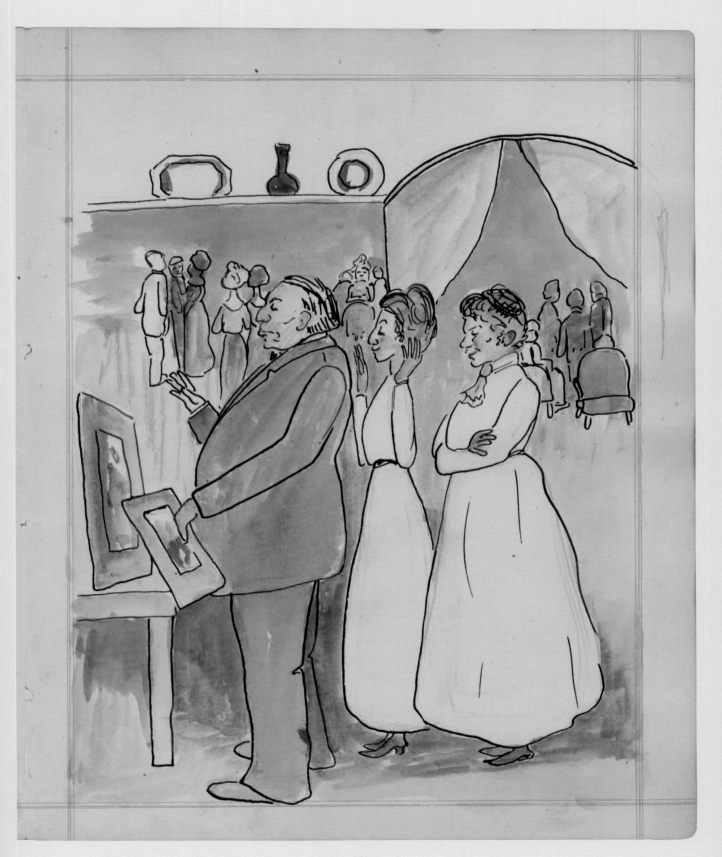

JULY 16 BANFF

BANFF IS A BEASTLY HOLE: HEAT INTENSE,
AND MOSQUITOES WORSE THAN LOUISE: THE HOTEL
IS CROUDED, AND THE FOOD POOR, WHILE RATES ARE
VERY HIGH! WE MEET TWO CHEERFUL AND
PAINFULLY ENERJETIC VICTORIANS, WHO HAVE
DERIVED GREAT BENEFIT FROM THE SULPHUR-BATHS,
AND ARE INDEFATICABLE IN DRAGGING US, GLORIFIED
BY HALO'S OF MOSQUITOES AND IN A PITIFULLY
WILTED CONDITION, TO SEE SULPHUR, SMELL SULPHUR,
AND DRINK SULPHUR.
I AM CONVINCED THAT SULPHUR, AND ALL
PERTAINING TO IT SOVOURS OF THE DEVIL.

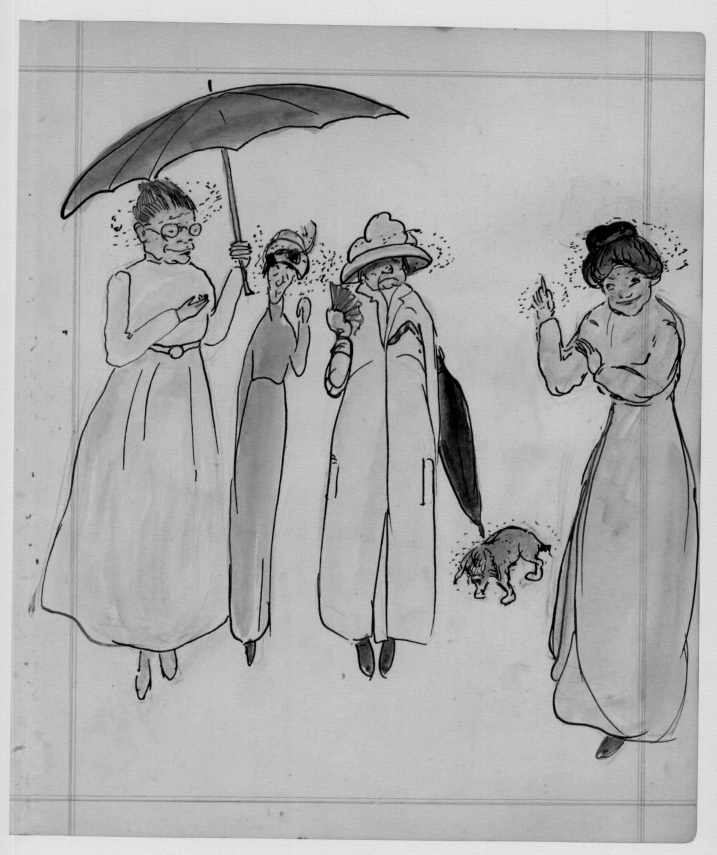

BANFF JULY 16

SISTER. HAS ALWAY PRIDED HERSELF ON HER
SMALL FEET BEHOLD HER CHAGRIN WE
GO OUT TALYHOEING SISTER BILLIE AND I ARE
ON THE BOX SEAT WITH THE DRIVER, THE
HILLS ARE PRECIPITIOUS, AND THE DRIVER
COMMANDS SISTER TO LEND A FOOT ON THE
BREAK. MARK THEIR FEET SIDE BY EACH ON
THE BREAK,

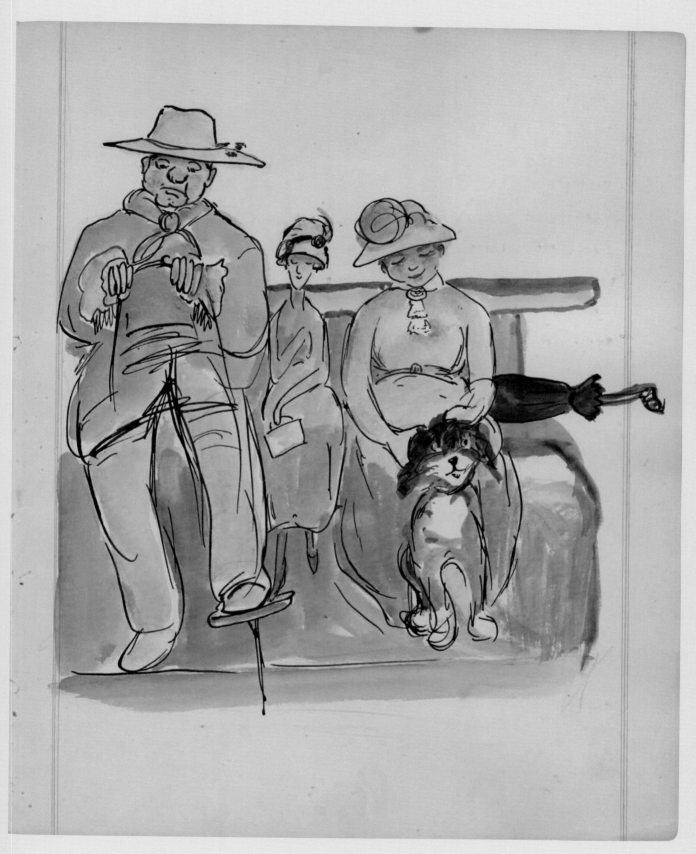

CALGARY JULY 14.

AN UNSPEAKABLY WRETCHED DAY: TRAIN CROWDED:
DUST FLYING: BABES YELLING: HEAT SWELTERING:
BRINGS US TO CALGARY ABOUT 4 P.M. 'BRAMER
LODGE' SWATHED IN GENTILITY AND BATHED IN
SULTRY HEAT, IS LOCKED IN A HOLY SABBATH
CALM. THE MANAGERESS. WITH A SMALL SLEEK
NOB OF HAIR RESEMBLING AN ONION. SITS AT HER
DESK WITH A DOG TO THE RIGHT AND A DOG
TO THE LEFT, STUDYING A BOOK OF SERMONS:
WHICH SHE GRUDGINGLY LEAVES TO ATTEND TO
OUR ACCOMODATION. THE PLACE ABOUNDS IN
DOGS WHO THIRST FOR WILLIAM'S BLOOD BUT
HE DISDAINS TO NOTICE THEM AND DINES OFF A
CHICKEN CARCAS LIKE THE GENTLEMAN HE IS.

38

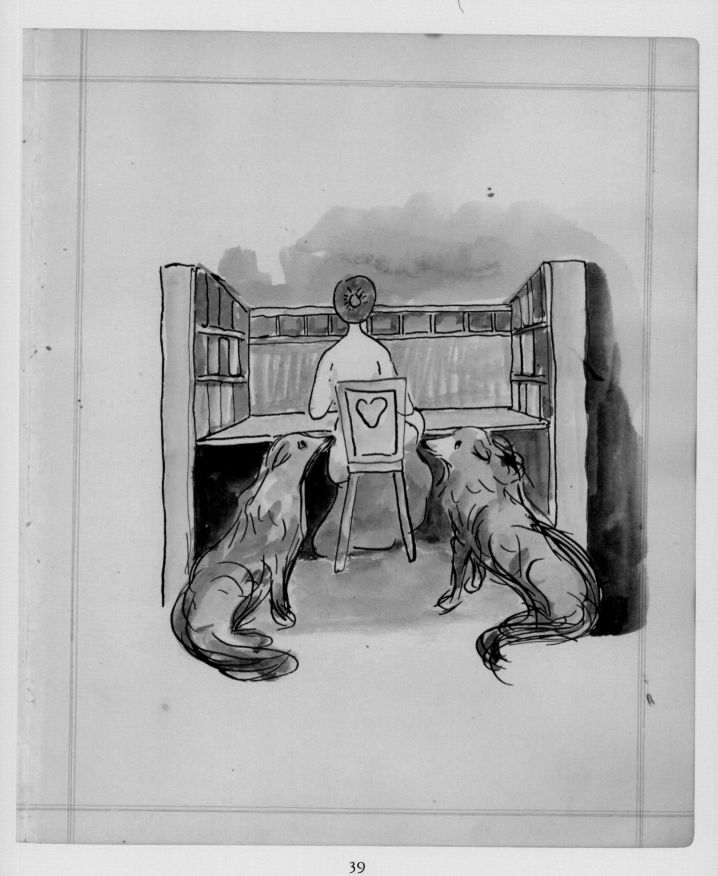

EDMONTON JULY 18.

"THAT," SAID WINNIE, POINTING TO A SQUIRMING PINK MORSEL OF HUMANITY IN A BASKET; "IS MY CHILD," BEING MYSELF IGNORANT ABOUT THE SPECIES, I MURMUR IT APPEARS TO BE AN EXTREMELY FINE CREATURE, SISTER GOES INTO EXTACIES OVER IT, AND BILLIE, (WHO HAS PREVIOUSLY BEEN INFORMED THAT HE IS TO MAKE HIS HOME HERE, FOR THE NEXT YEAR TO COME, AND BE A BROTHER TO IT) GIVES A SEARCHING GLANCE INTO THE CRADLE, FOLLOWED BY A SUPERCILLIOUS SNIFF, DURING THE WEEK OF OUR STAY I MADE SEVERAL UNFORTUNATE SLIPS, CONSEQUENT ON MYSELF ONLY POSESSING A FAMILY OF PARROTS AND BILLIE, ALLUDING TO ITS CRADLE, AS ITS COOP, AND ITS WAIL, AS ITS GROWL OR ITS SCREECH; MORTIFING SISTER AND BRINGING A CONTEMPTIOUS LOOK TO THE YOUNG MAMA'S EYE, BUT A GRIN TO BILLIE'S MUG, HE AND I ALWAYS UNDERSTAND ONE ANOTHER.

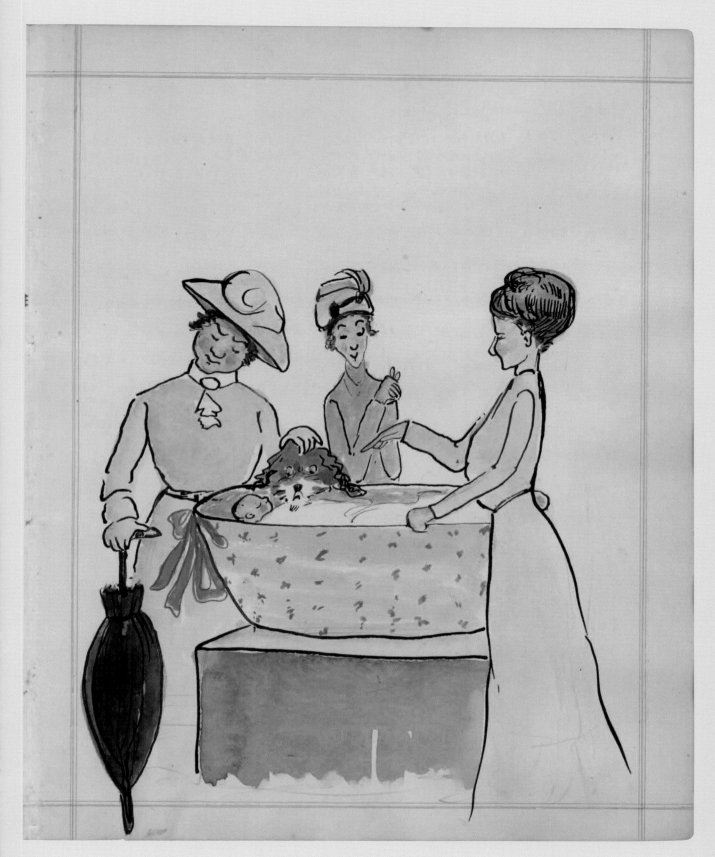

EDMONTON JULY 19

A HEAVY THUNDER STORM, AND DELUGES OF
RAIN. SISTER AND I MAKING A LITTLE EXPIDITION
INTO THE TOWN AFTER, HAVE A TASTE OF THE
EDMONTON MUD, A GLUTINOUS SUBSTANCE, OF A
SLIMEY, STICKEY, SLIPPERY, NATURE: BEFORE
GOING A BLOCK, YOUR BOOTS BECOME SO
ENCASED, THEY ARE THE SIZE OF A TOWN LOT
EACH, AND TOO HEAVY TO LIFT, AND YOU
ARE OBLIGED TO STOP AND CLEAR THEM
WITH STICKS BEFORE YOU CAN PROCEED.

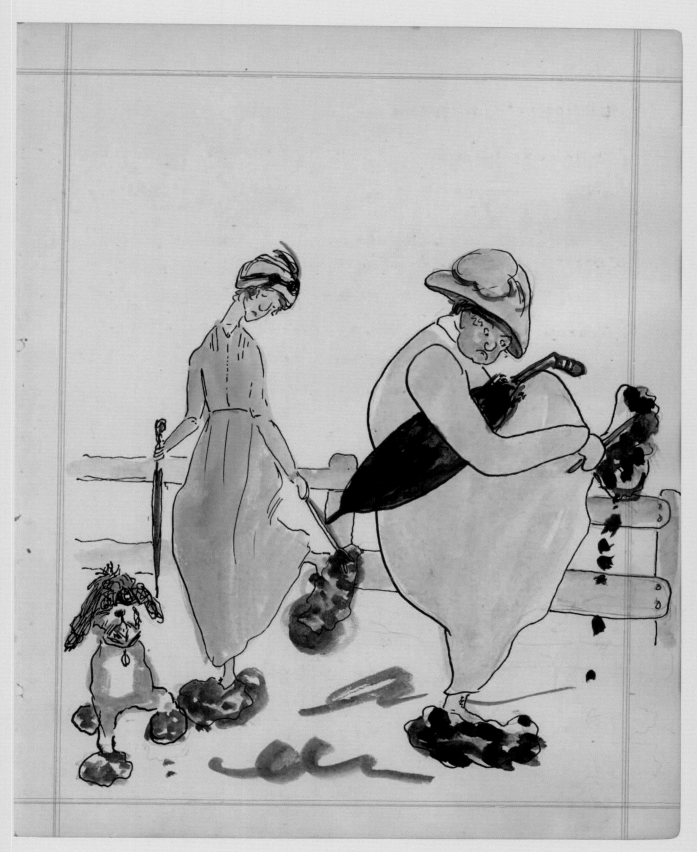

AND SO I LEFT HIM, WAITING, AND SO WILL I FIND HIM WAITING, WHEN THE YEAR IS UP, WITH THE WONDERFUL PATIENCE AND UNDERSTANDING OF HIS KIND.

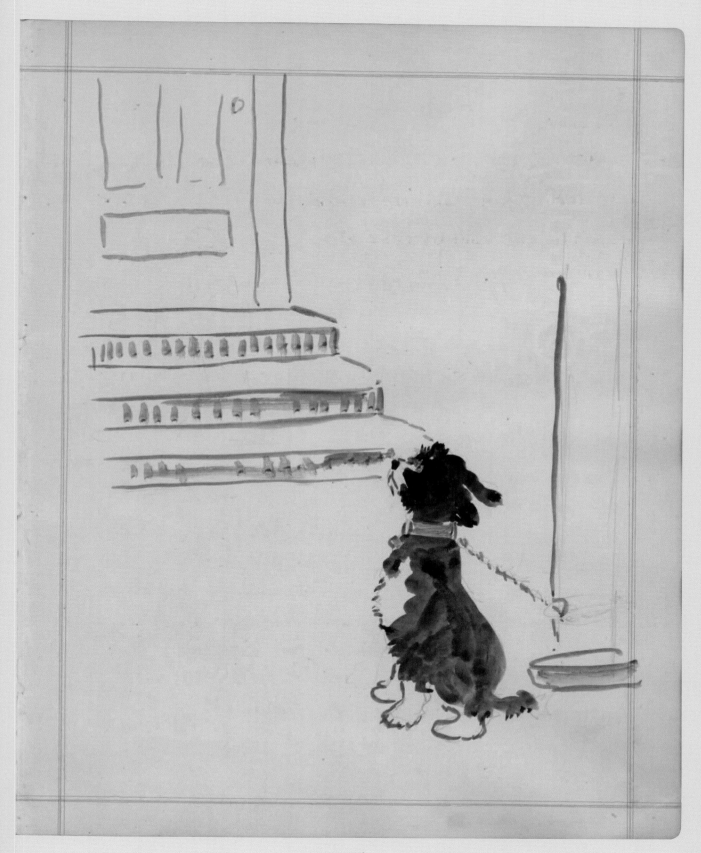

JULY 24 Calgary

ARRIVE IN CALGARY AGAIN AT 11 P.M.

HAVE A DELIGHTFUL MOTOR RIDE ALL ROUND THE SURROUNDING COUNTRY NEXT MORNING; LEAVING FOR THE EAST AT 2.30 .

OH THE TRIALS OF THE TRAIN! THE SEAT IN FRONT IS OCCUPIED BY A PAIR OF LOVERS, WHO IN SPITE OF THE HEAT, NESTLE CLOSE, SHE HAS LABRYNTHS OF FLAMING RED HAIR, HEATING TO EVEN LOOK AT, HE HAS A CROP OF SHORT BLACK SPIKES: AND THEY SUCK

CHOCOLATES: SO DISTASTEFUL IS THE SIGHT OF THIS PAIR TO US, THAT WE EACH GET INTO OUR MOST REMOTE CORNER, AND TRY TO SLEEP; MEANWHILE, THE VILLAIN IN OUR REAR, ROBS US OF OUR BAG OF JUICY PEACHES, AND WHEN WE AWAKE PARCHED WITH THIRST. AND IN A PEACHY FRAME OF MIND, THE EMPTY BAG LIES UNDER HIS SEAT, AND HE IS SNORING IN A LOUD AND FORCED MANNER.

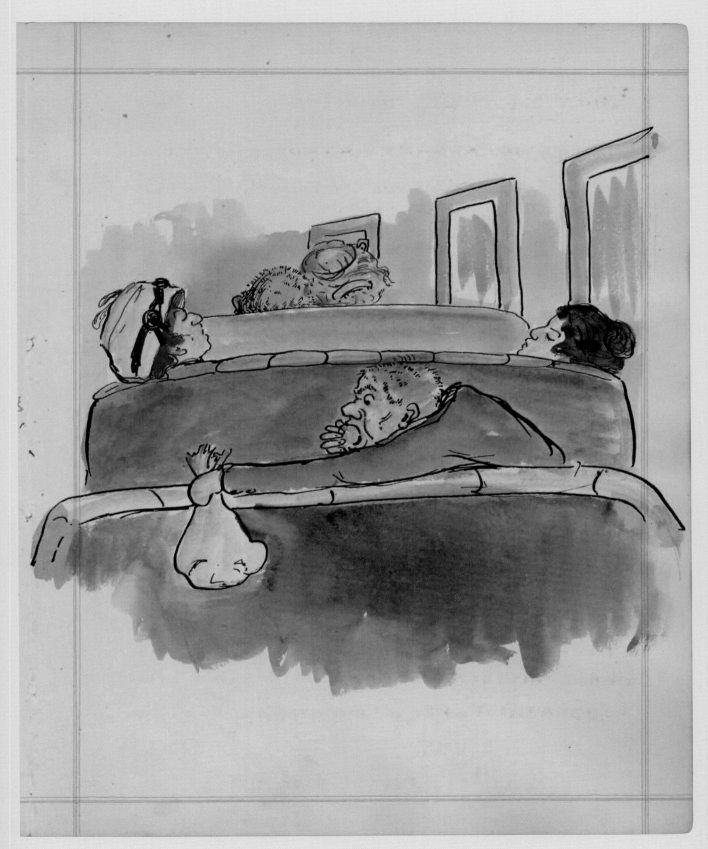

JULY 25 MEDICINE HAT

MEDICINE HAT IS A WONDERFUL LITTLE TOWN, PARTICULARLY NOTED FOR ITS NATURAL GAS, WHEREWITH THE TOWN IS LIGHTED, AND COOKED FOR; THE INHABITANTS ARE ALL VERY PROUD OF IT, AND BRAG AND BOAST CONTINUALLY ABOUT IT. CLIMBING A HILL TO OBTAIN A VEIW OF THE TOWN, WE SAT DOWN RATHER DUBIOUSLY, ON A DOME SHAPED EXCRESSENCE. TO REST, SISTER PO-POOED MY NERVOUS SUGGESTION THAT IT MIGHT CONTAIN NATURAL GAS AND BE UNSAFE; BARLEY WHERE WE SEATED, THAN THERE WAS THE MOST TERRIFFIC EXPLOSION, BOUNCING US CLEER INTO THE AIR WITH FRIGHT, FEELING OUR LAST HOUR HAD COME, I TURNED TO SAY FAREWELL TO SISTER, ENDEAVOURING TO KEEP 'I TOLD YOU SO' OUT OF MY EYE AS AN UNFITTING SPIRIT TO DEPART THIS LIFE IN: MY GLANCE HOWEVER WAS ARRESTED MIDWAY, BY TWO SMALL BOYS MAKING OFF WITH SPEED AND LOUD MIRTH, A BUNDLE OF SMOKING FIRECRACKERS STILL CLASPED IN THEIR GRIMY HANDS.

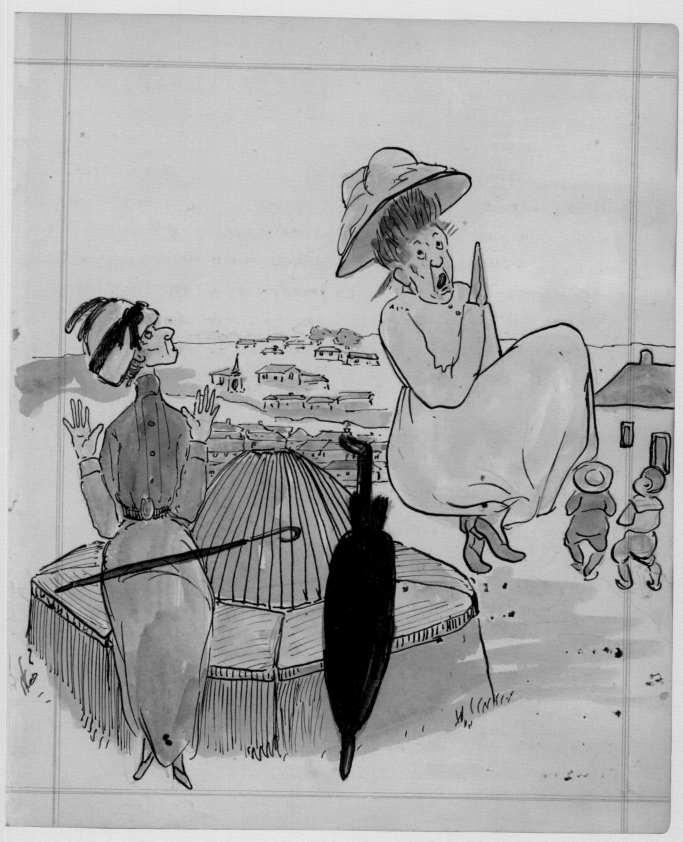

SHEWN TO OUR ROOM A SPACIOUS TWO BEDDED APARTMENT AT MEDICINE HAT, OUR SENSATIVE NOSES WHERE AT ONCE ARRESTED BY THE OVER POWERING SMELL OF DISENFECTANT, A CONVICTION IMMEDIATELY SEIZED ME, SOME ONE HAS JUST DIED HERE, SEE, I SAID, POINTING TO A DISCOLOURED SPOT ON THE CARPET, THE VERY SPOT WHERE THEY FELL, AND FALLING ON MY KNEES, I LOWERED MY NOSE TO SEE IF THE DISENFECTANT ODOUR PROCEEDED FROM THIS SPOT, SISTER WAS SCORNFUL, AND OPINED THAT THE RADIATOR HAD LEAKED AND THAT I WAS FUSSY, HOWEVER, AT MY EARNEST REQUEST SHE ACCOMPANIED ME TO THE MANAGER TO SOLICIT ANOTHER ROOM, HE WAS MOST OBLIGING AND SENT THE GENERAL ASSISTANT TO MOVE OUR BAGS.

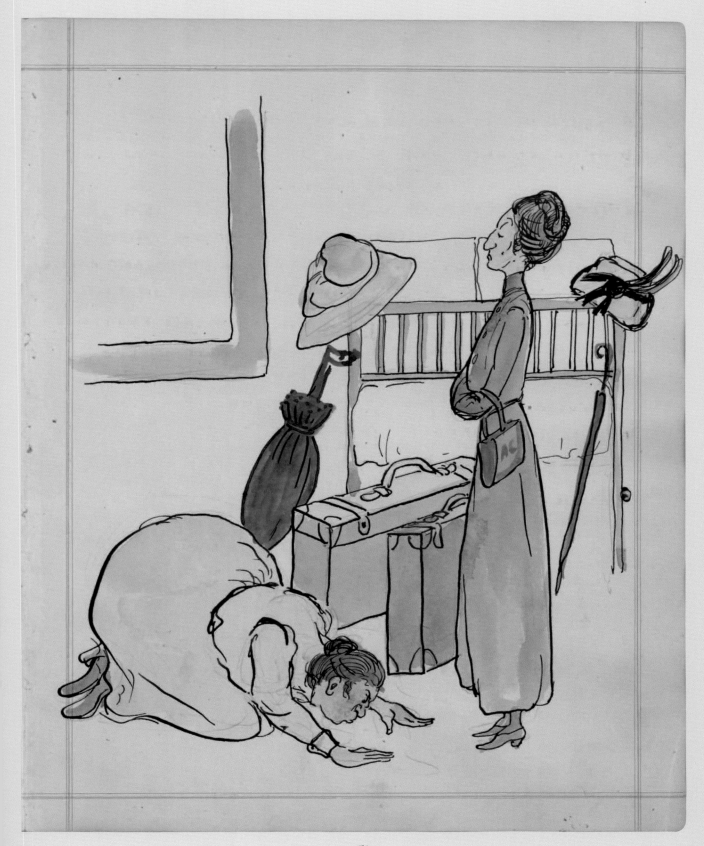

THE SMELL OF THE NEXT ONE WAS HOWEVER JUST AS OVERPOWRING AS THE FIRST: MUST BE A MORGUE" WE MURMURED, TO EACH OTHER; THEN, IN FALTERING VOICE TO THE MAN "HAS ANY ONE DIED HERE LATELEY?" THE OLD MAN LOOKED AMAZED AT MY QUESTION 'NO' HE SAID 'BUT WE'VE BEEN A O'USE CLEANING' WE ALLAS SCOWERS WITH DISENFECTANT ONCE AYEAR.' BUT SAID HE 'ERE'S A 'HUNCLEANED' ROOM YE CAN 'AVE: BUT THE ODOUR EMITTING FROM ITS PORTAL, DECIDED US TO CHOOSE THE DISENFECTED SMELL, SO HAVING MADE A SMELLING TOUR ALL ROUND THE HOTEL WE WENT BACK AGAIN TO OUR ORIGONAL CHAMBER. AND PREPARED OURSELVES FOR REST BY THE BLINDING AND STUPENDOUS GLARE OF THE NATURAL GAS. ILLUMINATION.

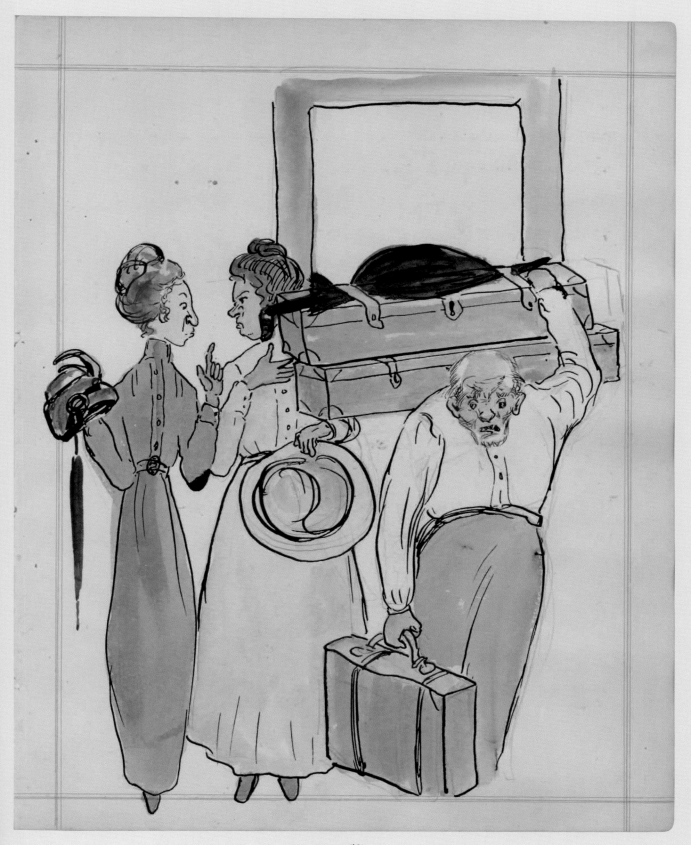

PASSING THROUGH THE OFICE TO MAIL A LETTER
BEFORE RETIRING, WE CAME UPON THE PORTER
TELLING THE MANAGER ALL ABOUT IT, THEY WERE
BOTH OVERWHELMED WITH AMUSEMENT AT OUR EX-
PENSE. AND LOOKED VERY GUILTY AS WE PASSED.

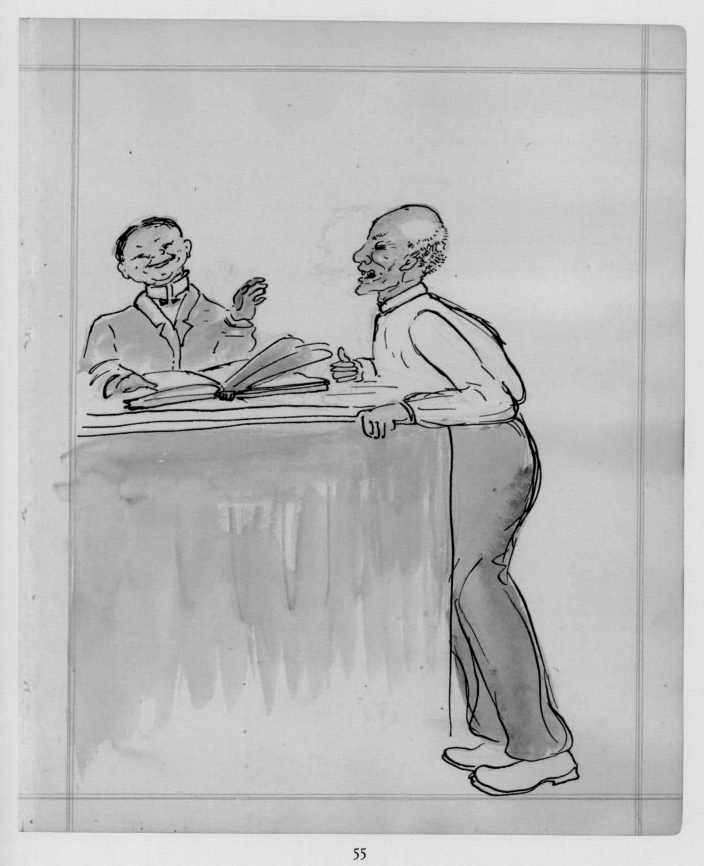

BROADVIEW JULY 26.

BROADVIEW HAS NO NATURAL GAS, NOR ANY
UNNATURAL GAS EITHER, FOR THAT MATTER; WHEN
WE ARRIVED BETWEEN 10 AND 11 AT NIGHT, INKY
DARKNESS PREVAILED, CONSEQUENTLY POOR SISTER
ALIGHTED ON THE PLATFORM, BALANCED ON HER
NASAL ORGAN, DOING IT MUCH DAMAGE, ALSO FEARING
A FEARFUL GASH IN HER NEW TRAVELLING COS-
TUME, THE PRIDE OF HER HEART AND THE ENVY
OF MINE ALL THE TRIP. SHE WAS CONSIDERABLY
SHAKEN IN BODY AND RILED IN SPIRIT.

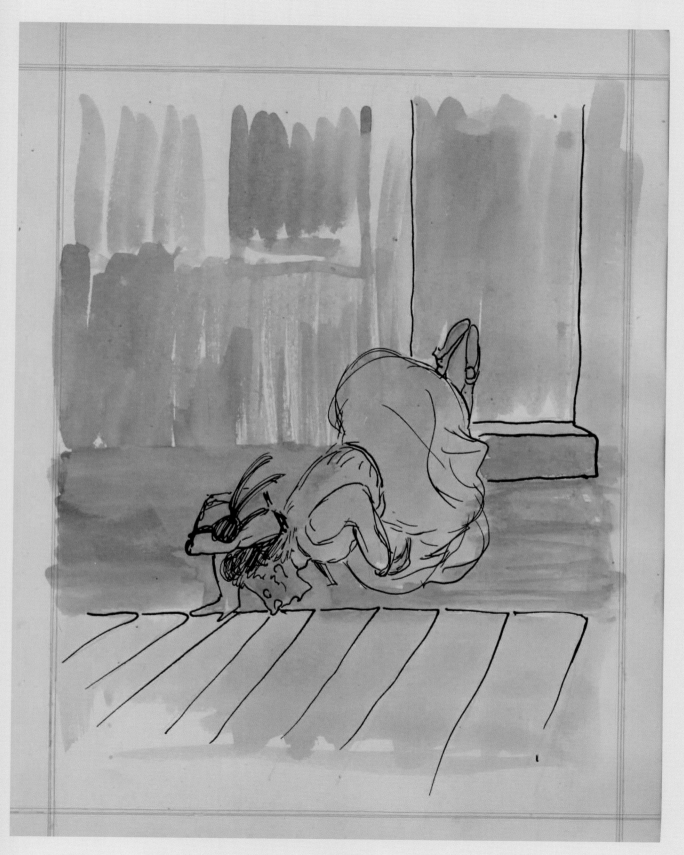

NEXT MORNING.

AFTER A BRISK WALK AROUND 'BROADVEIW'
(HUNTING FOR THE VEIW WHICH WE FAILED TO FIND)
WE TOOK TRAIN AGAIN AND HAD A GASTLY JOURNEY
TO WINNIPEG, THE TRAIN WAS CROUDED TO THE
VENTILATORS, THE MAJORITY OF THE PASSENGERS
BEING INFANTS IN ARMS, AND THE REMAINDER
INFANTS OUT OF ARMS AND IN EVERY BODY ELSES
WAY, EVERY SECOND AFRESH WAIL RENT THE AIR,
AS ONE GOT TRAMPED ON, OR BUMPED ITS HEAD
WHEN THE TRAIN JOLTED, OR FELL OFF A SEAT IN
SLUMBER, IT APPEARED THERE WAS SOME SHOW
ON IN REGINA, HENCE THE RUSH, AND FROM
THE APEARANCE OF THE PASSENGERS, WE
PRESUMED IT WAS A BABY SHOW.

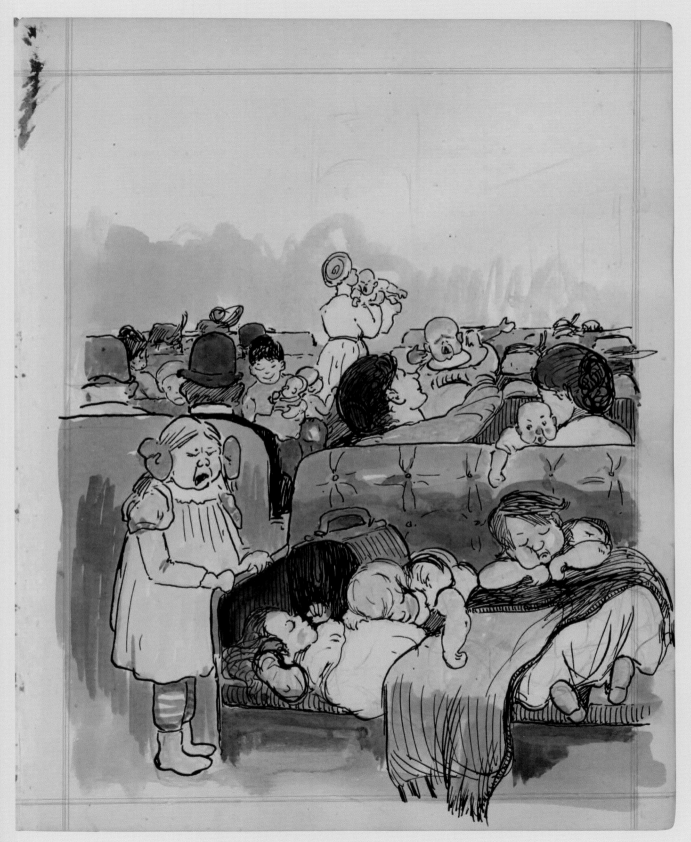

59

WINNIPEG JULY 27.

AMID MUCH LOUD NOISE AND EXCITMENT OUR
TRAIN PULLED INTO WINNIPEG. THE PORTER
HAVING MUCH ADO TO EXTRICATE US FROM OUR
COATINGS OF DUST, INDEED WE RESEMBLED
A TRAINFUL OF GREY RABBITS, UNTIL HE GOT
BUISY WITH HIS BRUSH, ALL CHANGED AT WINNIPEG
AND WE HAD A CONSIDERABLE WAIT, I AMUSED
MYSELF WATCHING A WEARY MOTHER WITH A LARGE
FAMILY OF FLATFOOTED CHILDREN, WHOSE THROATS
APPEARED PERPETUALLY PARCHED. THEY LOOKED
LIKE A BROOD OF DUCKS, AS THEY WADDLED BACK
AND FORTH TO THE FILTER AND DRANK AUDIBLY OUT
OF THE PUBLIC TINCUP, THE SMELLY DARK BROWN
WATER WHICH WAS QUITE WARM.

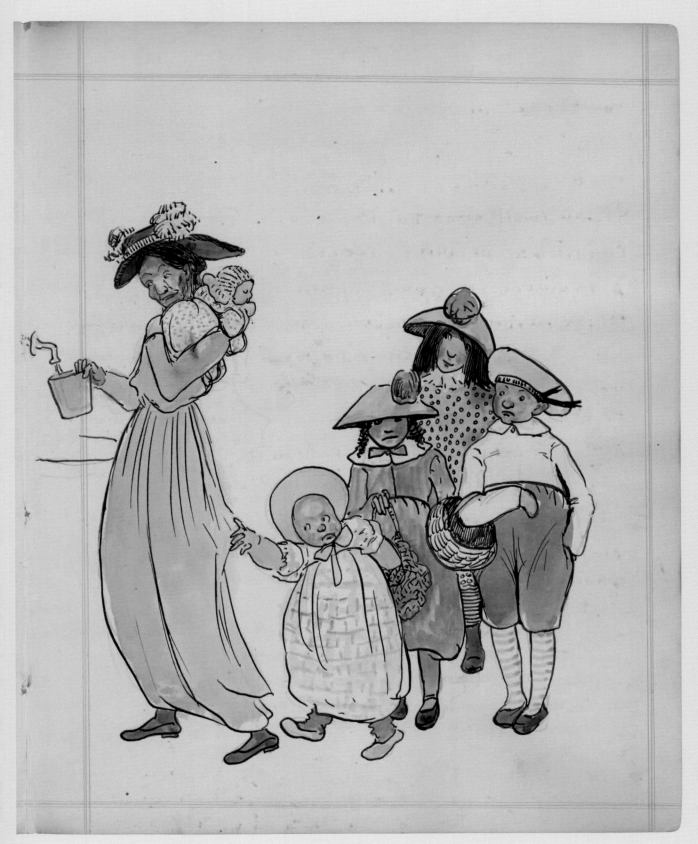

MONTREAL. JULY 29

MONTREAL AND CHANGE FOR QUEBEC.

WE REACHED MONTREAL ABOUT SIX P.M. TIRED,
AND FEELING VERY GRIMY, OUR SOULS YEARNED
FOR HOT BATHS, BUT THE TIME WAS NOT YET:
WE WERE TOLD TO WAIT TILL THE BUS CAME,
TO TAKE US TO THE STATION FOR QUEBEC, AND
WAIT WE DID, MANY WEARY HOURS: AS IT NEARED TEN,
AND STILL NO SIGN OF A BUS, WE BECAME FAMISHED
BUT DARE NOT LEAVE THE WAITING ROOM, FOR FEAR OF
THE BELATED BUS FINALLY I COULD ENDURE NO MORE
SO NOSED ROUND TILL I FOUND A LUNCH COUNTER, AND.
HERE ONE AT A TIME, WITH THE OMNIBUS ON OUR
CHESTS THE WHILE, WE WRESTLED WITH STALE DOUGHNUTS
AND VILE COFFEE: TWAS WELL WE WERE THUS BRACED. FOR
THAT MEMORABLE BUS RIDE, UNLIKE ANY THING IN OUR
PREVIOUS EXPERENCE, WE WERE PITCHED SIDEWISE, HEAD-
LONG, SINGLY, AND EN MASSE. ALL WAYS AT ONCE; WE CEASE
FINALY TO STRUGGLE AGAINST THE INEVITABLE AND HUDLING
OUR PERSONS INTO BALLS, WE RESIGNED OURSELVES TO
BOUNCING: PERIODICALLY WITH A VIOLENT UNIVERSAL CONCUSSION
THE VEHICLE WOULD STOP, AND ONE OR MORE BALLS WOULD
BE HURLED TO THEIR DESTINATION. OURS WAS THE LAST
STOP, AND THE DRIVERS VOICE WAS AS SWEET MUSIC
TO AS HE YELLED "NOW ALL THE RIST O' YEZ GIT OUT!

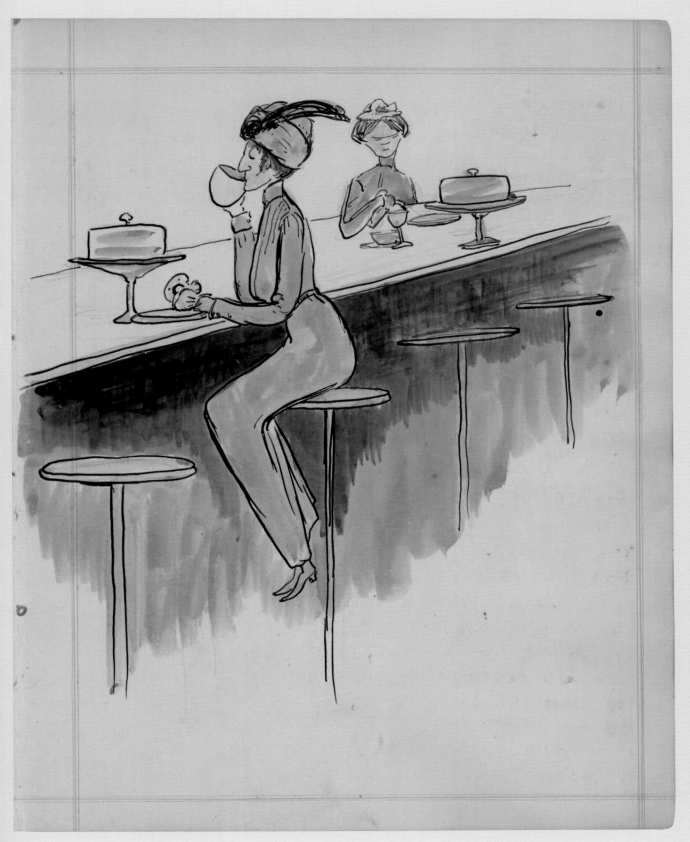

JULY 30 QUEBEC.

WITH EYES DREAMY WITH ROMANCE, (OR BLEARED WITH SLEEP) WE GAZED FROM OUR PULMAN WINDOW TO SEE WONDERFUL HISTORIC OLD QUEBEC. AROUND WHICH OUR IMAGINATIONS HAD WOVEN MANY DREAMS, OUR EYES LIT ON A FOLORN EMPTY STATION, WITH THE WIND HOWLING THROUGH IT, AND THE RAIN POURING IN TORRENTS OUTSIDE, WE WERE BODILY AND MENTALY DAMPED, A DEJECTED MILK MAN KINDLY GAVE VENT TO PROLONGED HOUL, WHICH AWAKENED ONE OF THE CABBIES, WHO WERE SUNK IN TORPID STUPIDITY WAY DOWN INSIDE THEIR WATER PROOF APPARATUSES. AND WE STARTED UPHILL FOR THE HOTEL DISILLUSIONED BUT BOUYED UP WITH THE HOPE OF A GREAT STACK OF LETTERS AWAITING US AT OUR HOTEL, BUT THE MOST SEARCHING ENQUIRIES FAILED TO PRODUCE ONE, AND FEELING NEGLECTED AND DESPAIR WE SEEK OUR ROOM TOO DEJECTED EVEN TO DISCUS IT. THE NEXT MATTER IS TO SEND TO THE BAGGAGE ROOM FOR OUR TRUNK SENT, DIRECT FROM HOME, TO AWAIT OUR ARRIVAL, WHEN THE BOY RETURNED WITHOUT IT, AND THE INTELLIGENC IT HAD NEITHER BEEN SEEN NOR HEARD OF, WE COLLAPSED IN BLACK DESPAIR. WE WERE ALSO BLACK FROM TRAVEL AND " OUR BITTEREST WOE,
 WAS NO CLEAN CLOE."

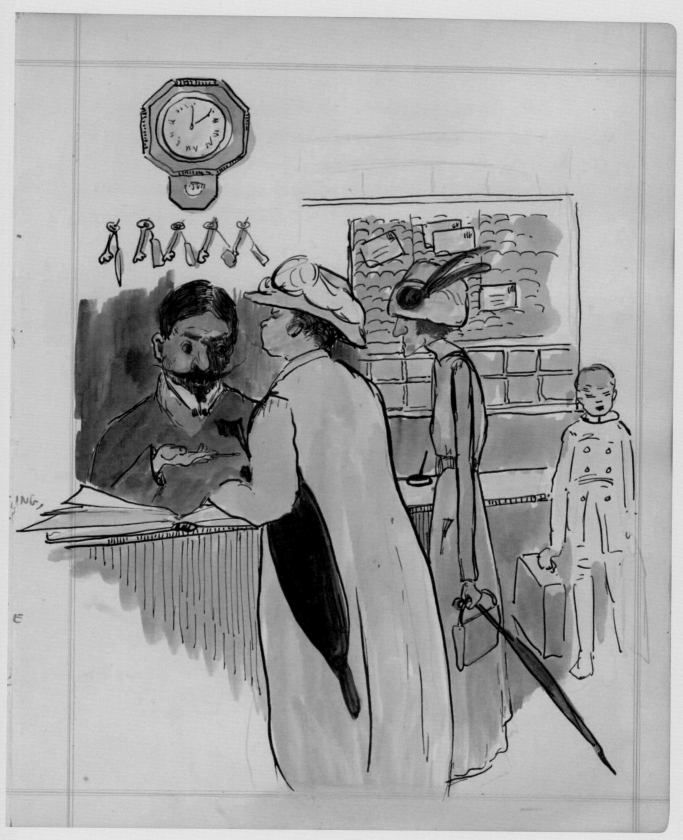

WE DETERMINED ON A PERSONAL INVESTIGATION OF THAT C.P.R. BAGGAGE-ROOM. THERE WAS ONLY A WEAK LEGGED SICKLY YOUTH IN CHARGE, BUT NEITHER SISTER'S PLEADING NOR MY THREATS, PRODUCED THAT TRUNK, FINALLY WHEN I HAD REDUCED HIM TO A STATE OF WRITHING TERROR, I EXTRACTED THE INTELLIGENCE. "IT WENT ABOARD THE BOAT SAILING YESTERDAY" WHY IT SO EAGERLY TOOK TO SEA BY ITS LONELY, HE, NOR WE, NOR NOBODY KNEW. AND HEAPING MALEDICTIONS ON HIS SANDY HEAD, AND ON ALL C.P.R. OFFICIALS IN GENERAL, WE MARCHED FROM THE OFFICE TO THE NEAREST LAUNDRY GOING OUT ONLY AFTER DARK TILL WE HAD RESULTS.

BAGGAGE ROOM C.P.R.

Where's their Trunk

OUR NEXT WORRY WAS THE INFORMATION CON-
VEYED TO US BY THE HOTEL MANAGER, THAT HE
COULD ONLY HOUSE US FOR TWO DAYS, AS THE
"KNIGHTS OF COLUMBUS" WERE ABOUT TO SWOOP DOWN
UPON QUEBEC FOR A CONVENTION, HAVING PREVIOUSLY
ENGAGED EVERY ROOM IN EVERY HOTEL AND EVERY
AVAILABLE ONE OUT. THIS FORCED US INTO AN
AGONIZING SPELL OF 'ROOM HUNTING, THE 'KNIGHTS
OF COLUMBUS' HAD BAGGED EVERYTHING BUT ATTICS,
WE TOILED UP THOUSANDS OF STAIRS AND INSPECTED DOZENS
OF UNSAVORY APPARTMENTS, AMID INTENSE HEAT PUNCTUATE
WITH ROARING THUNDER STORMS, FINALLY LOCATING WITH
A FRENCH FAMILY, WHICH THREW MY VOCABULARY OUT
OF BUISNESS. AND BROUGHT SISTER INTO PROMINENT &
SUPERIORITY.

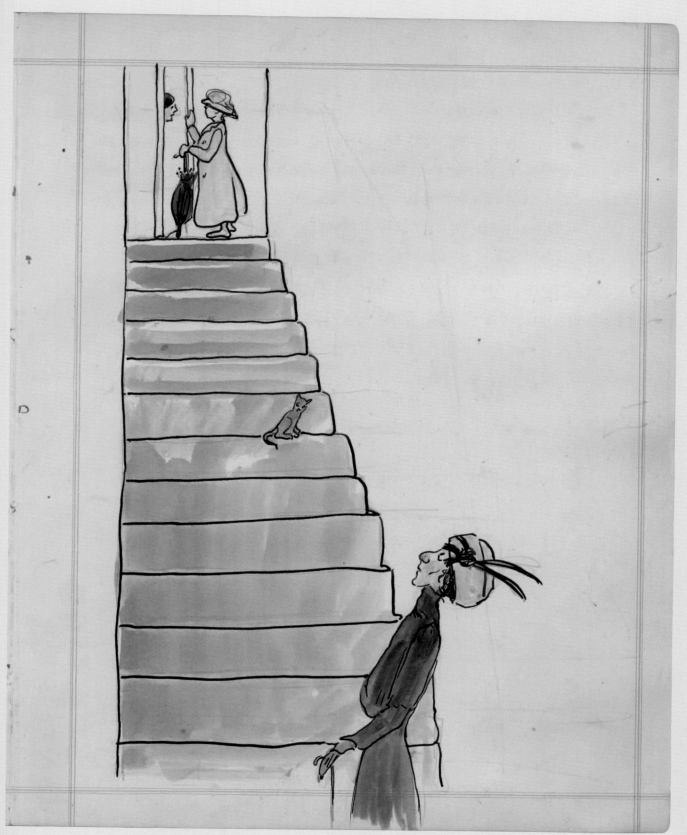

OUR FIRST NIGHT IN THIS LOCALITY OF FOREIGN JARGON, I TOOK TO MY BED WITH A RACKING HEADACHE, WHILE SISTER BETOOK HERSELF TO CHURCH, I WAS JUST SETTLING TO SLEEP, WHEN MADAM APPEARED AT MY BEDSIDE WITH A LONG SPEEL OF HER GIBBERISH QUITE INCOMPREHENSIBLE TO ME, I SHOOK MY ACHING HEAD AND LET HER CONTINUE, BUT THE GOOD LADY HAD NO INTENTION OF WASTING ALL HER WORDS, RUSHING TO THE DOOR SHE BROUGHT IN MONSIEUR, AND HER SON, AND THEY ALL MADE A DEAFNING BABEL, BRANDISHING WATER JUGS AT ME THE WHILE, AT LAST COMPREHENSION DAWNED! THE HOUSE MUST BE ON FIRE! I BEGGED THEM IN ENGLISH AND CHINOOK (THE ONLY LANGUAGES AT MY COMMAND) TO RETIRE AND LET ME DRESS, BUT THEY BECAME MORE HEATED AT THE CHINOOK, AND STAYED WITH IT TILL SISTER CAME IN OPEN MOUTHED IN ASTONISHMENT, AT THE COMMOTION AND INTERPRITATED. "DID I WISH SOME FRESH DRINKING WATER." — I WANTED ENOUGH WATER TO DROWN THE ENTIRE FRENCH-SPEAKING POPULATION OF QUEBEC,

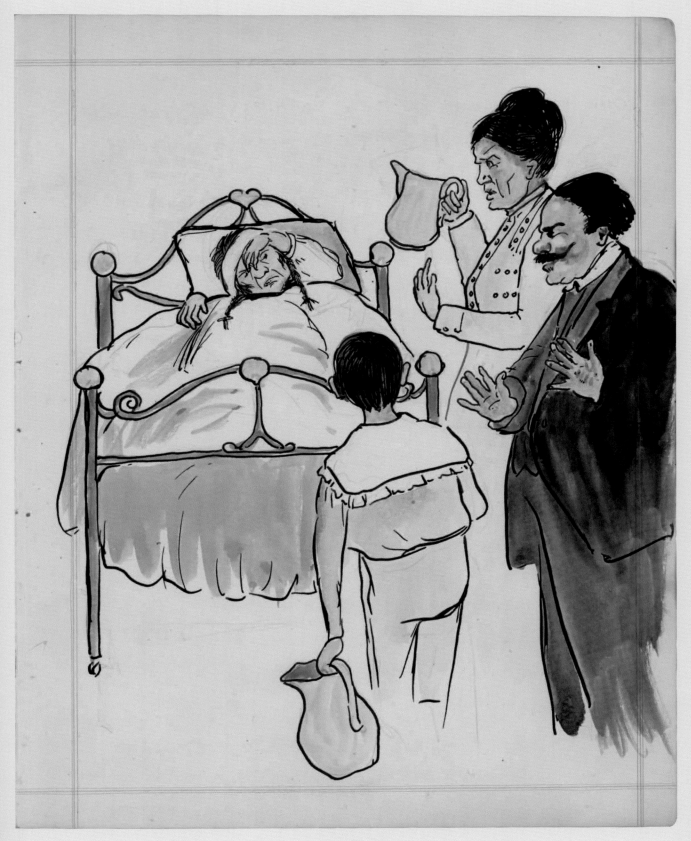

71

ALMOST EVERY DAY WE WERE IN QUEBEC
THERE WAS A VIOLENT THUNDER STORM.
OUR FIRST EXPERIENCE WAS IN AN ELECTRIC
TRAM. THE ELECTRICITY WAS TURNED OFF AND
WE HAD A LONG WAIT, THE FAINT HEARTED
FOLK AROUND US WERE AFRAID. WERE WE?
OH MY NO! WE'RE WESTERNERS WE JUST
SAT CLOSE TO KEEP WARM.

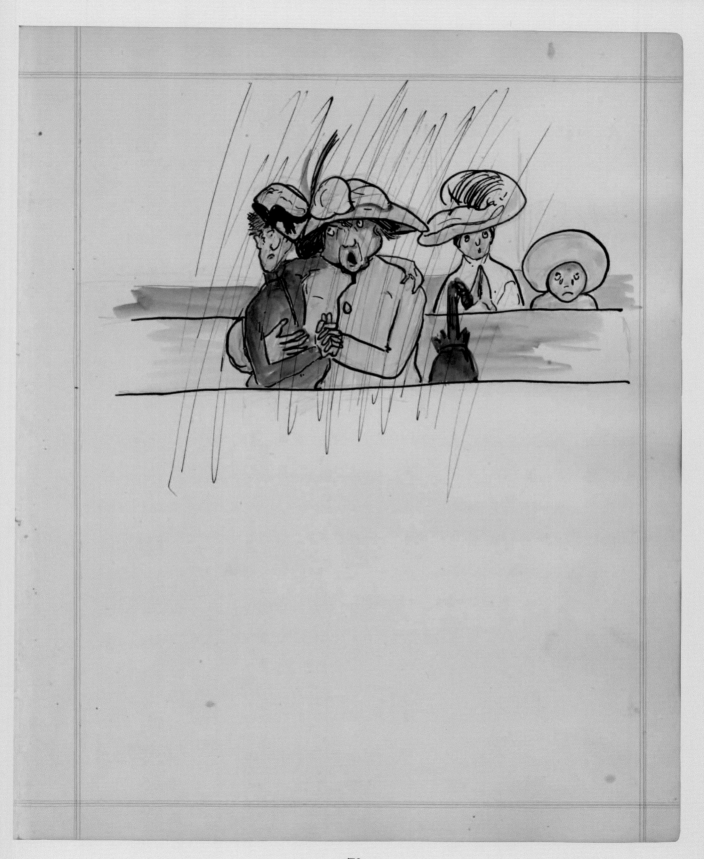

THE RESTURANTS IN QUEBEC ARE <u>ABOMINABLE</u>, ONLY THE MOST SUBTLE TACT, PREVENTED SISTER AND I FROM HAVING A SERIOUS DIFFERENCE OVER THEM. SHE IS A 'HERBALIST,' I AM AN 'ALL ROUND EATER.' THEREFORE, THE RESTURANT OF HER CHOICE, WAS NOT THE RESTURANT OF MY CHOICE, AFTER ALTERNATELY HAVING <u>FAILURE</u> DINNERS. BY ~~SHARING~~ ^{ENJOYING} EACH OTHERS SOCIETY. WE SENSIBLY DECIDED TO GO OUR OWN WAYS AT MEALTIMES, MEETING IN THE PARK AFTERWARDS; HAVING TICKLED OUR PALATES AND AVOIDED FRICTION. THERE IS ONLY ONE OTHER CAUSE OF DISAGREEMEMT THAT SISTER AND I EVER WRESTLE OVER VIZ. UMBRELLAS, I FAVOUR THE LARGE USEFUL PLEBIAN VARIETY, SHE, THE SMALL, USELESS, ORNAMENTAL, VARIETY HIGHLY PATRICIAN, THIS LITTLE DIFFERENCE OF OPINION HOWEVER WE HAVE SETTLED SATISFACTORILY LIKEWISE BY EACH ADHERING STAUNCHLY TO OUR OWN CONVICTION OF THE FITNESS OF THINGS, AND IN QUEBEC WE HIT UPON AN APPALATION FOR MINE, WHILE LIVING AMONG THE FRENCH, THAT APPEALED TO SISTERS ASTOCRITIC TASTES AND DID NOT OFFEND MINE VIZ THE "GRAND PARAPLUIE". NOW SISTER RESPECTS MY GAMP.

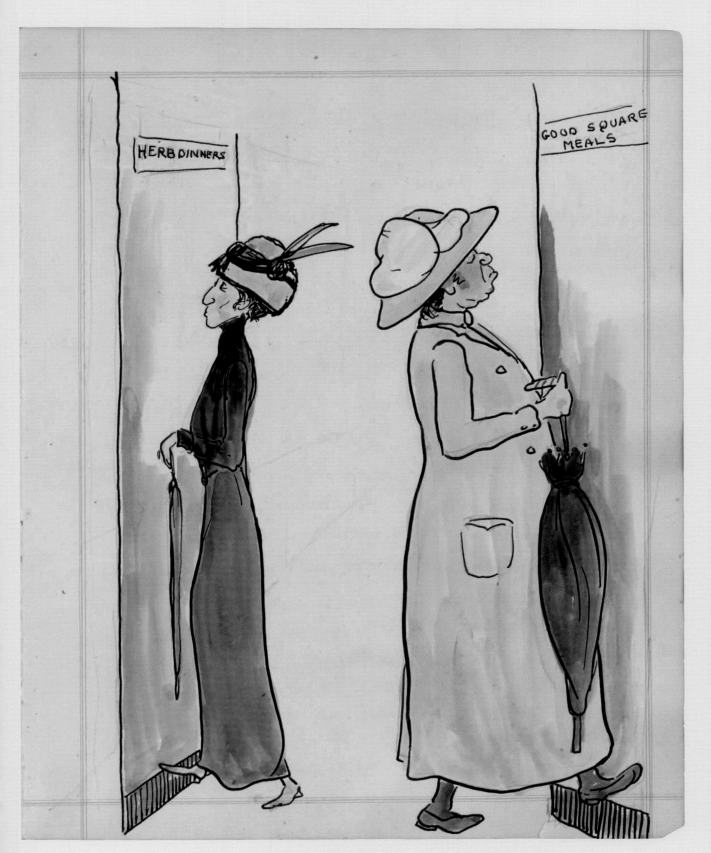

STILL NO LETTERS FROM HOME AND WE ARE
PROSTRATE WITH ANXIETY.

WE PARTAKE OF WATER WAFERS AND BANANAS
IN OUR APPARTMENT, SISTER IN HER THISTLE
BESPRINKLED DRESSING GOWN, IS VERY DEJECTED,
SHE WOULD NOT CUSS HERSELF, BUT I CAN SEE
SHE TAKES SOLID COMFORT OUT OF MY RUNNING
RUMBLE OF CUSSES, THO' SHE WOULDENT BLACKEN
HER OWN SOUL WITH THEM.

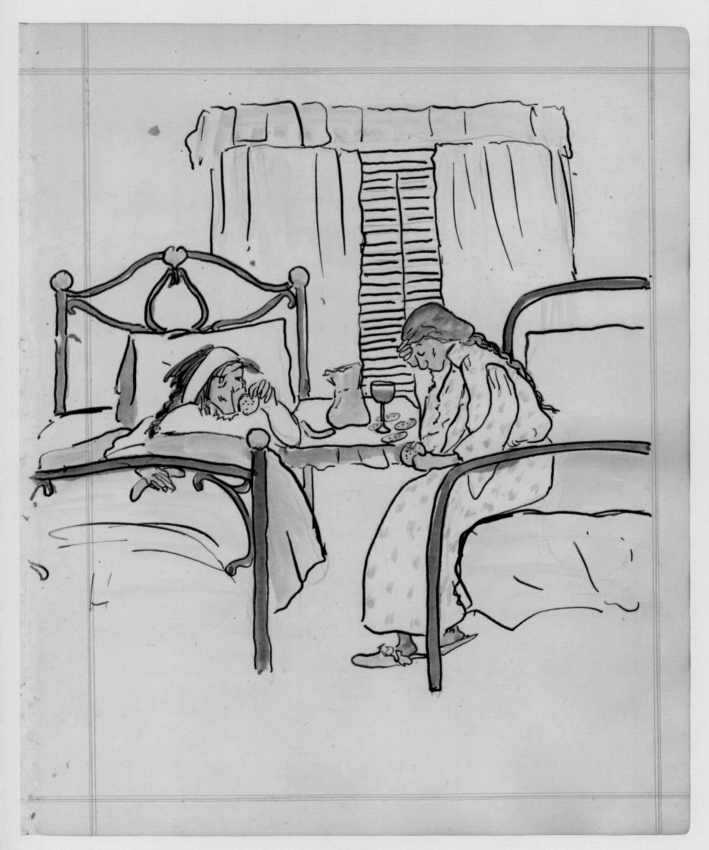

AND THEN THEY COME! THOSE LONG LONGED-
FOR LETTERS: PUPS PARROTS AND SISTERS ALL WELL:
UP GO OUR SPIRITS: AND OFF WE START TO
"DO" QUEBEC, NOSING INTO ITS HIGH SMELLING
ANTIQUITIES, AND REVERENTIALLY OBSERVING
ITS MONUMENTS.

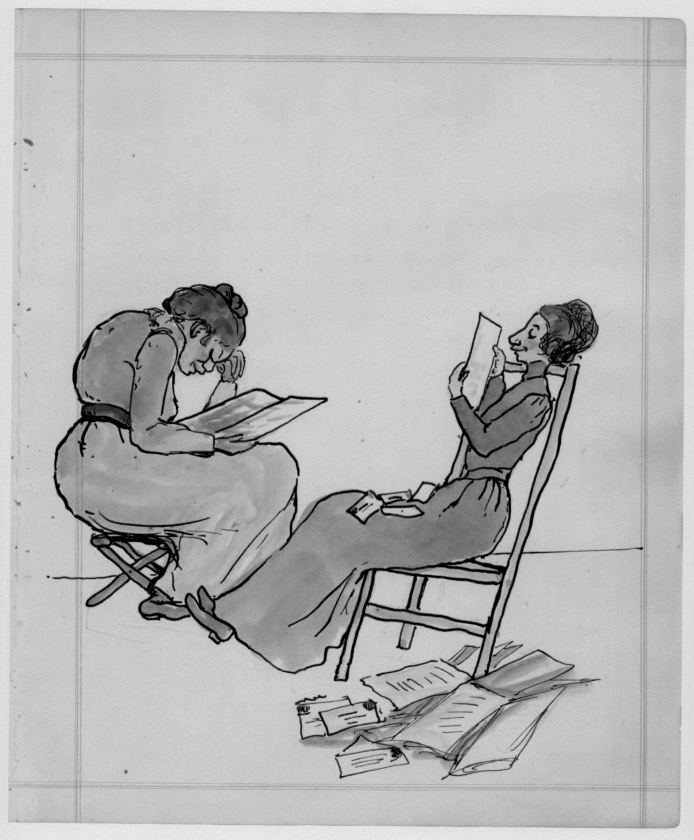

DOWN IN LOWER TOWN THERE ARE SOME 'OLD CURIOSITY SHOPS.' WHILE IDLY GAZING IN THE WINDOWS, I BECAME MADLY DESIROUS OF POSESSING A TEA SET OF ANTIQUE PEWTER, TO USE IN MY STUDIO, AND THEREBY CAUSE MY FREINDS PANGS OF JEALOUSY; POSSIBLY I SHALL LEAD THEM TO BELEIVE IT IS AN OLD FAMILY HEIRLOOM; SISTER THINKS THAT WOULD BE DISHONOURABE BUT AIDS AND ABBETS ME, PATTING HER PURSE IN A SUGGESTIVE WAY THAT MEANS PECUNIARY ASSISTANCE TO THE SCHEME, AND WE ENTER THE SHOP WITH OUR BARGAINING INSTINCTS KEENLY ON THE ALERT.

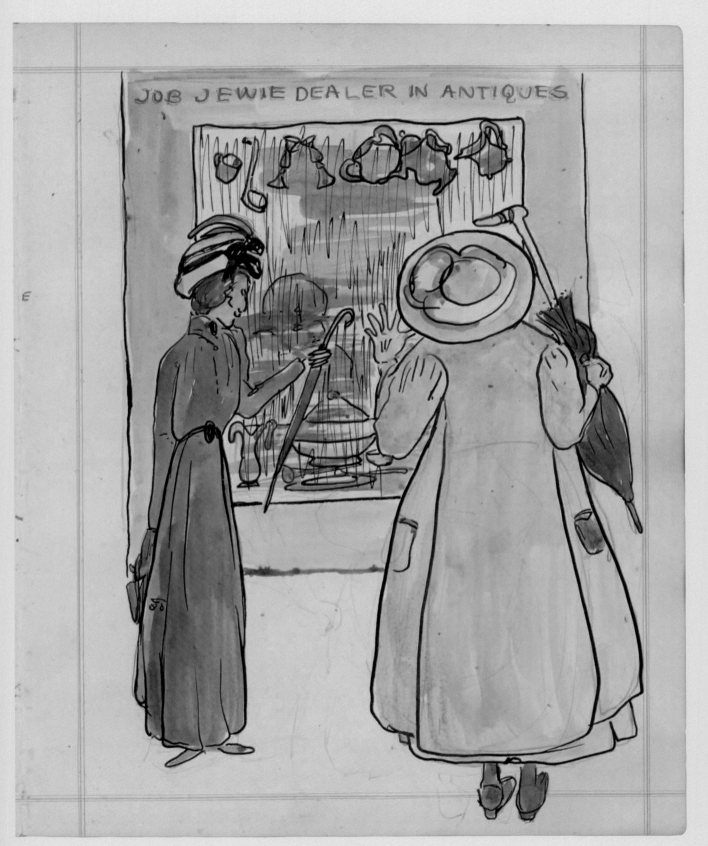

IN ABOUT AN HOUR WE IMMERGE, LADEN WITH
BULKEY PARCELS, AND WITH THAT PECULIARY
SELFSATISFIED FEMININE EXPRESSION, SIGNIFICANT
OF HAVING MADE A <u>SHREUD</u> BARGAIN: STOPPING
AT ONE OF THE BEST JEWELERS TO PURCHASE
SOME OF THE MOST <u>RELIABLE</u> AND <u>EXPENSIVE</u>
PLATE POLISH MADE.

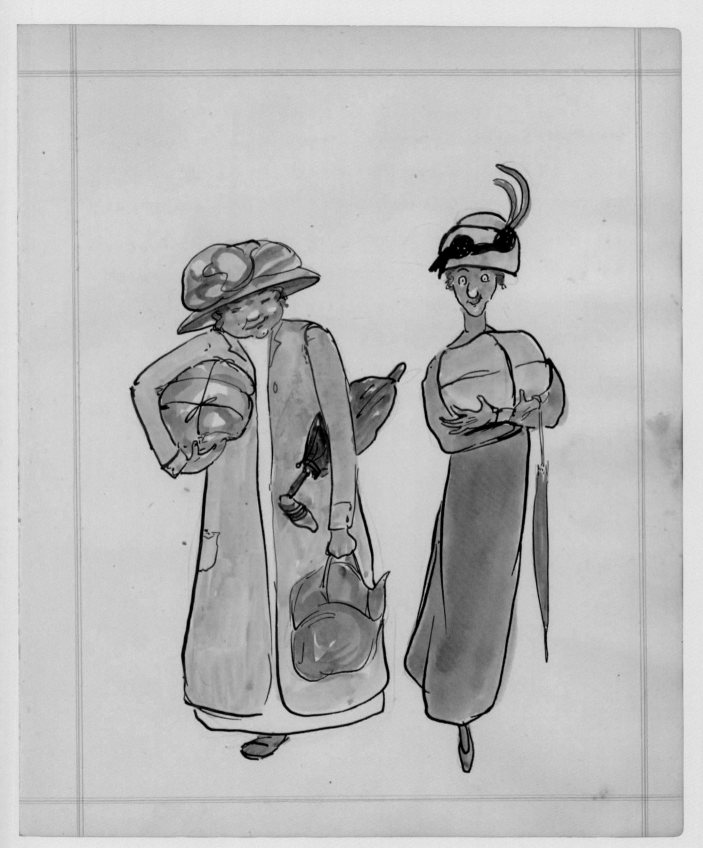

WHAT THO' IT DOES STORM AND THUNDER OUT-
SIDE. WE ARE BUISY, AND THE BRILLIANT POLISH
ON THE PEWTER OUTRIVALS ANY SUN SHINE: WITH
SLEEVES ROLLED HIGH, AND FACE WROUGHT PURPLE
BY THE EXERTION I APPLY POLISH AND ELBOW-GREASE
WHILE SISTER EXAMINES THEM WITH KINDLY
INTREST AFTER EVERY RUB, FOR THREE DAYS
WE ARE THUS EMPLOYED THEN —

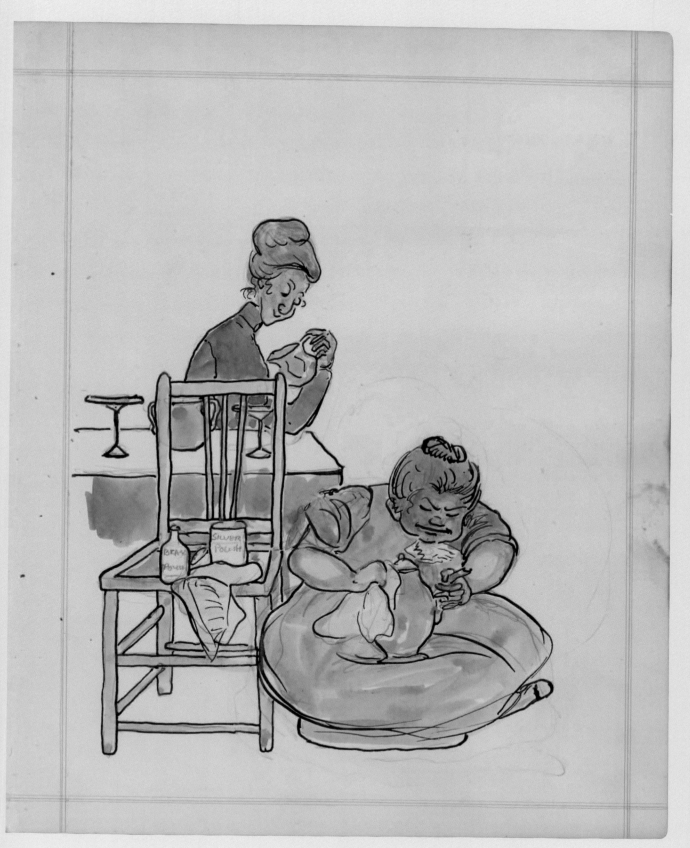

THE DIRT BEING REMOVED, I DESCOVER THE
FRAUDULENT ACTION. OF "JOB JEWY", ON THE BOTTOM
OF THE TEAPOT IS WRIT 'STIRLING ELECTRO PLATE SHEFFIELD'
AND I PURCHASED IT UNDER THE TITLE OF ANTIQUE
FRENCH PEWTER. : THRUSTING THEM INTO A BASKET
I SOUGHT THE NEAREST JEWLER AND BESOUGHT HIM
TO 'NAME THE METAL 'WHY LEAD SAID HE' MAYBE
THEY HAD A COAT OF SILVER ONCE, BUT THAT'S
BEEN POLISHED CLEAN OFF. THERE MUCH TO LEARN
IN LIFE.

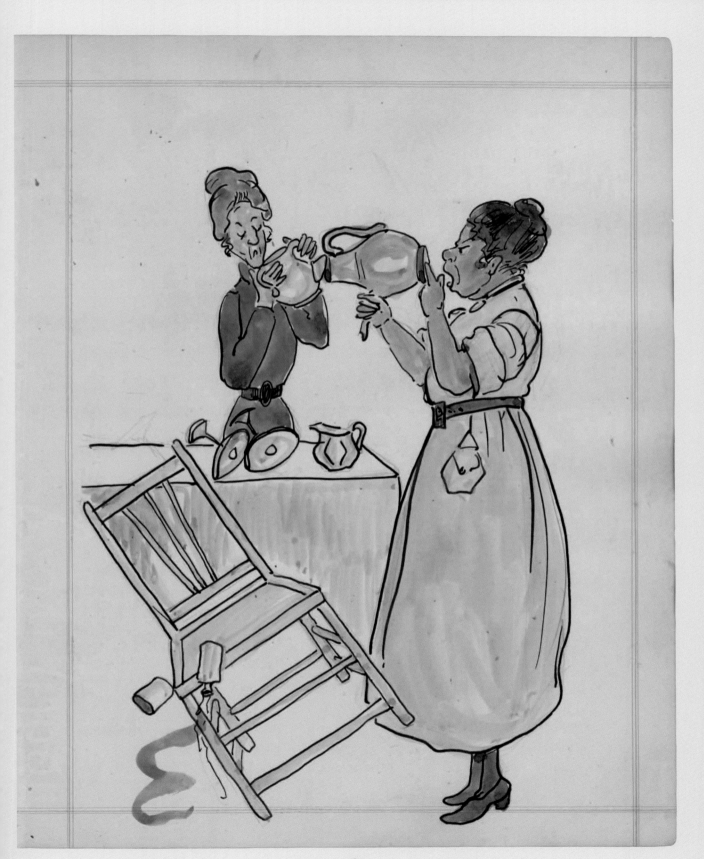

'FINDING OUT' WAS A BLOW NOT ALONE TO MY
AMBITIONS. BUT TO MY IDEALS OF HUMAN NATURE
AND INTEGRITY; OUR STAY IN QUEBEC BEING OF TOO
SHORT DURATION TO PROSECUTE, I LEFT THE MATTER
TO JOB JEWY'S CONSIENCE, WHICH I TRUST RENDERS
HIM SUPREME IRRITATION. AND SUPPLIED MYSELF
WITH AN ABUNDANCE OF EXCEEDINGLY LIGHT LITRATURE,
THEREBY TRYING TO TURN MY THOUGHTS INTO ANOTHER
CHANNEL. SHUTTING AS IT WERE 'PEWTER' OUT OF
MY LIFE FOREVER: I KINDLY BUT FIRMLY FORBADE
SISTER TO MENTION IT IN MY PRESENCE. WHICH
SHE KINDLY AGREEDTO, SITTING MEANTIME WITH
HER LITTLE FEET UPON THE FRAUDULENT SUGAR
BASIN. WHICH HAD BEEN CAST WITH ITS FELLOWS
UNDER THE TABLE.

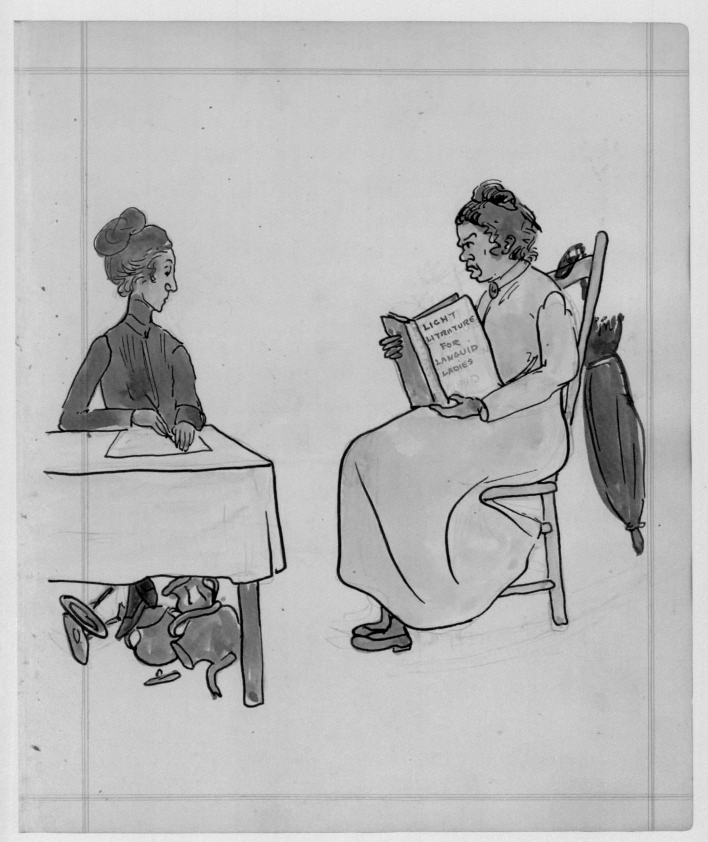

BEING AS IT WERE IN A CHASTNED AND SUBDUED
FRAME OF MIND OWING TO OUR DISSAPOINTMENTS AND
AFFLICTIONS. WE MADE A PILGRAMAGE TO THE
SHRINE OF ST ANNE DE BEAUPREY WHICH WAS BOTH
CALMING AND INSTRUCTIVE.
HERE THE HALT THE BLIND THE MAIMED AND THE
CONSCIENCE STRICKEN (I LOOKED FOR JOB JEWY. BUT SAW
HIM NOT) COLLECT TO DRINK THE MIRACULOUS WATERS
THE CHURCH IS FILLED WITH THE CRUTCHES AND SPECTACLES
OF THOSE WHO NEED THEM NO MORE, WE HOVERED IN THE
OUT SKIRTS OF THE THRONG, REJOICING THAT WE WERE
NEITHER BLIND, NOR LAME, AND THAT OUR CONCIENCES
WERE AT LEAST FREE OF FRAUD.

90

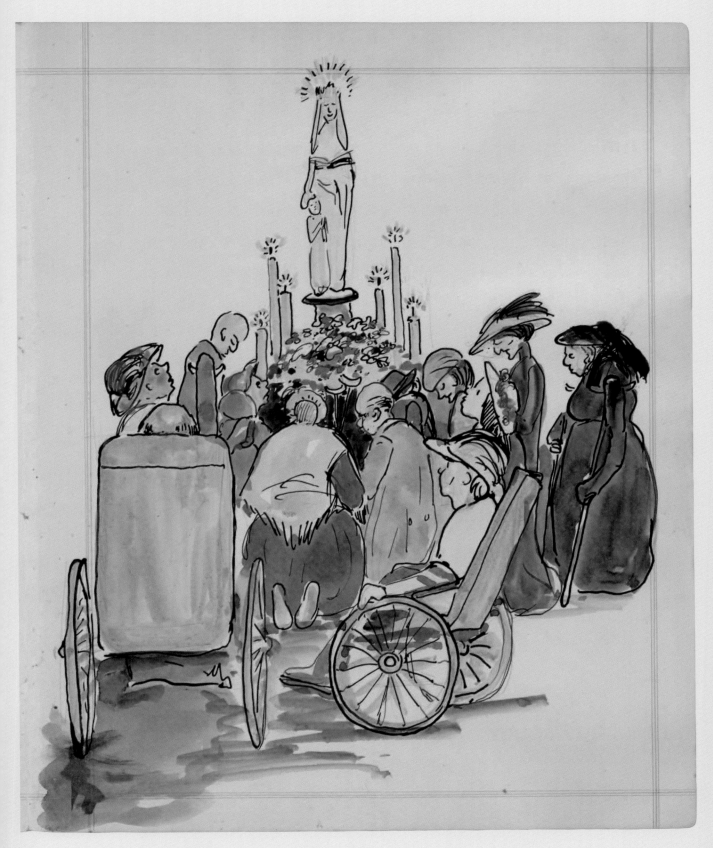

Aug 9

WE TOOK TRAIN TO 'LE GUARDIEN ANGE' A SWEET
PEACEFUL VILLAGE, WHERE THEY WERE A HAYMAKING,
AND SPENT A TRANQUIL DAY OF RURAL PLEASURE;
SISTER PORTRAYING 'FEILD FLORA', WHILE I READ
'RUSTIC LOVE TALES' AND WE BOTH SUCKED SWEETS.

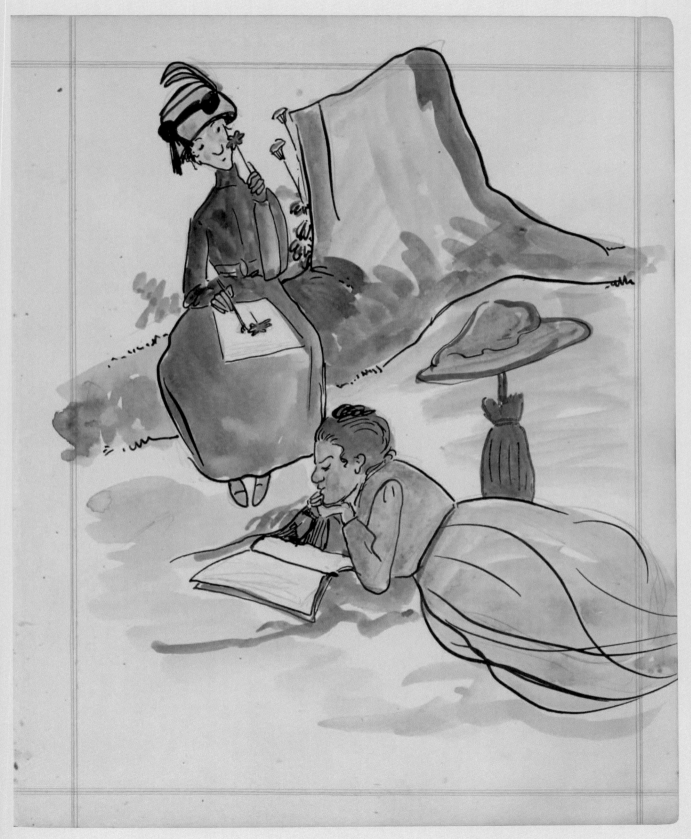

QUEBEC IS SURROUNDED BY MANY QUAINT VILLAGES, WHICH WE ENJOYED EXPLORING CERTAIN CHARISTERISTICS PERTAINED TO THEM ALL VIZ — ALL THE CHILDREN HAD BOW LEGS AND SQUINT EYES : ALL THE CATS ARE TORTORSHELL AND VERY LEAN. ALL THE MEN PLAY CROQUET ON MUD LAWNS RESEMBLING DUCK PENS. ALL THE HOUSES ARE CLOSELY SHUTTERED WHICH GIVES A MOST FOLURN LOOK TO THE PLACE, AND ALL THE GARDENS THO' GREEN HAVE NO FLOWERS.

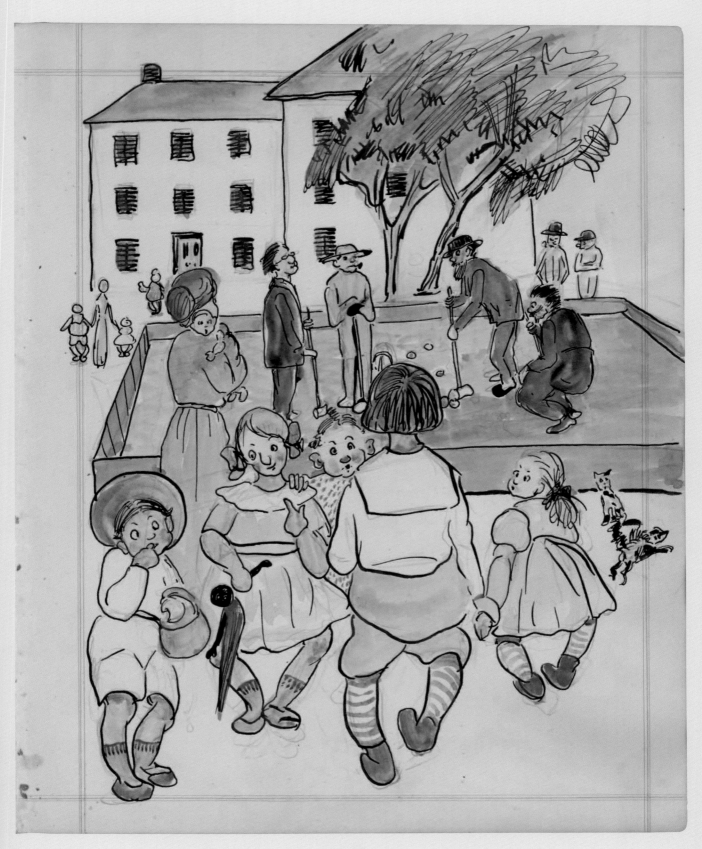

AND NOW CAME TIME TO EMBARK ON THE EMPRESS OF
IRELAND FOR LIVERPOOL ALL OUR WARM AND SEA FARING
CLOTHES WERE UNFORTUNATELY IN OUR LOST TRUNK
SISTER AFTER MUCH FITTING AND REFITTING GOT A
QUEBECIAN COAT. BUT I STOUTLY REFUSED TO FOLLOW
HER EXAMPLE, FEELING THAT, THE C.P.R. HAVE LOST MY
CLOTHES, AND THAT I WILL IN A WAY EVEN UP ON C. P. R.
BY EMBARKING ON THEIR VESSEL LOOKING DOWDY AND
ILL DRESSED: I DID BUY A RUG FOR THE DECK, IN
WHICH I INTENDED TO SWATHE MY SELF, AND FORLORNLY
PROMENADE ~~THE DECK~~ A SPECTLE OF REPROACH TO
THEM: 'AT LEAST' PRAYED SISTER, "FOR MY SAKE
HAVE YOUR LINEN DUSTER WASHED IT <u>IS</u> SO SPOTTY"
I HUMOURED HER IN THIS, AND THE WRETCHED THING
SHRUNK SO IMMODERATELY, IT WAS BARELY MORE
THAN AN EATON JACKET; AND I WAS OBLIGED TO CARRY
MY ARMS AT RIGHT ANGLES; AND INDEED MY DIS-
COMFITURE WAS SO GREAT I TOOK TO MY BED
BUT MY MISERIES APPARENTLY MADE NO IMPRESSION
ON THE C.P.R. WHATEVER:

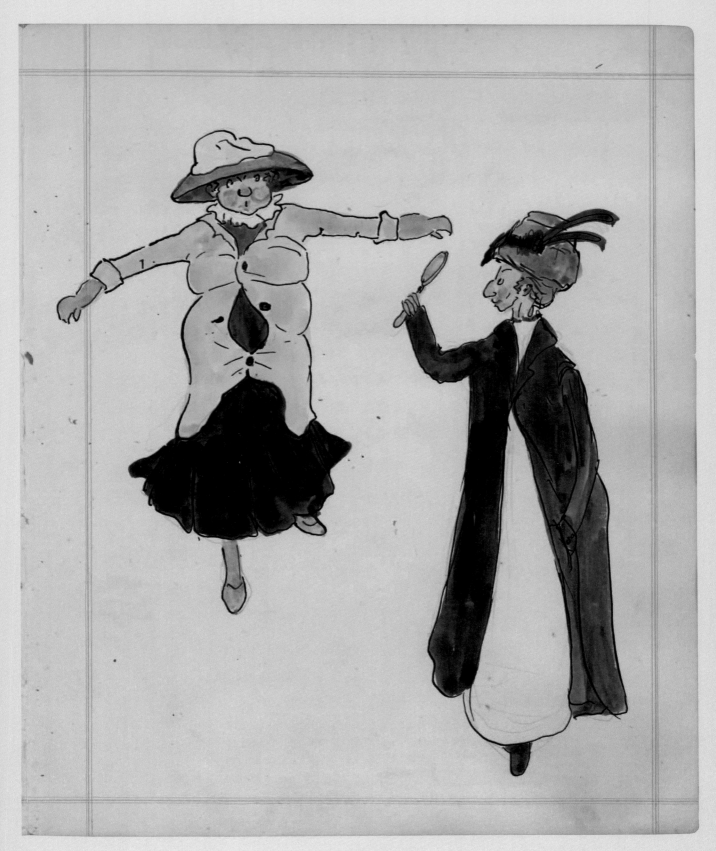

I SUFFUR FROM 'MAL DE MER', SISTER DOES NOT,
THEREFORE SISTER FAVOURS THE SEA AND A NAUTICAL LIFE,
WHILE I ABHOR SHIPS, SEA, AND ALL PERTAINING THERETO,
ON STARTING THIS VOYAGE I WAS BUOYED UP BY ONE
FRAIL HOPE VIZ — "MOTHER SILL" I ADORED AT THE SHRINE
OF "MOTHER SILL", PATRON SAINT OF THE SEASICK, I PURCHASED,
AND IN AGONY SWALLOWED, HER NOXIOUS CAPSULES WITH
WHAT I DEEMED MY LAST BREATH, AND THEN HEROICALLY
'LAY FLAT' TRUE THEY MAY HAVE SAVED ME FROM DEATH,
(THO' AT THE TIME I DID NOT REGARD THAT IN THE
LIGHT OF A BLESSING) A CAUSE OF MUCH DISTRESS TO
ME WAS THE FACT THAT MY PASSAGE MONEY WAS
CLEAR GAIN TO THE C.P.R., AS MY KEEP CONSISTING
OF WATER AND BISCUITS, COST NEXT TO NOTHING
THE FIRST DAY AT SEA THE GROUP OF ADORERS
ROUND MOTHER SILL'S SHRINE, WAS DENSE, AND SHE
DID A HUGE BUISNESS IN PILLS, BUT AS SOON AS
THE SEA WAXED ROUGH.

"THE ADORERS ALL IN THEIR BERTHS LAY PRONE"
"AND COLDLY LEFT MOTHER SILL ALONE"

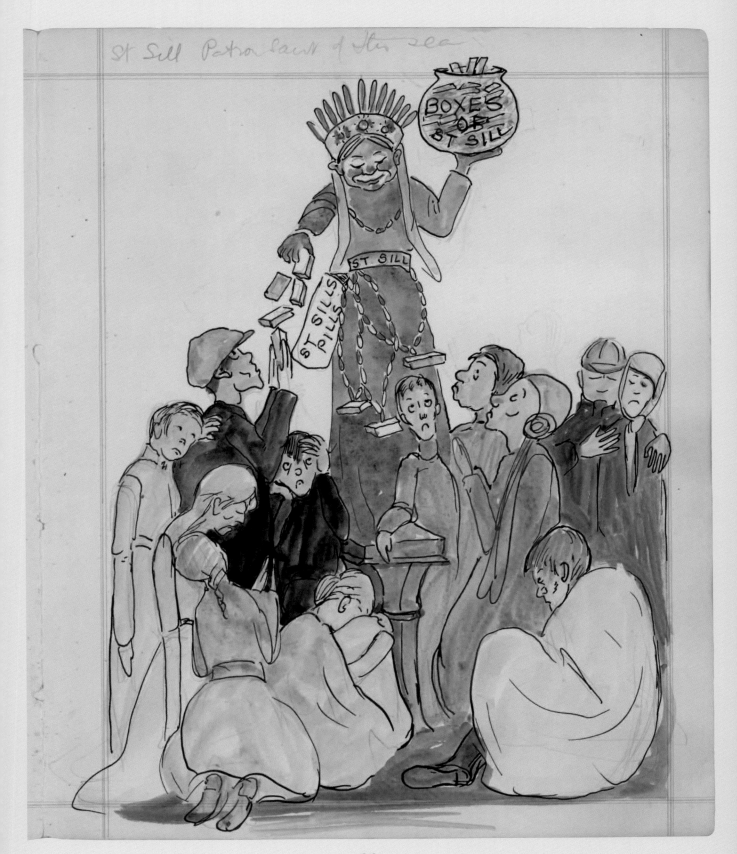

THERE WAS A HIGHLY IRRITATING AND NOXIOUS
OFFICAL ON BOARD, KNOWN AS THE 'INSPECTOR', HE
WAS A SELF SATISFIED MONSTER, WHOSE CHEIF DUTY
(AND PLEASURE) WAS SPY-CATTING AND ORDERING
PEOPLE ROUND, HE INTERFERED WITH EVERY ONE,
FROM THE CAPTIAN TO THE STEERAGE PASSENGERS.
AND WAS VENEMOUSLY DETESTED BY ALL.

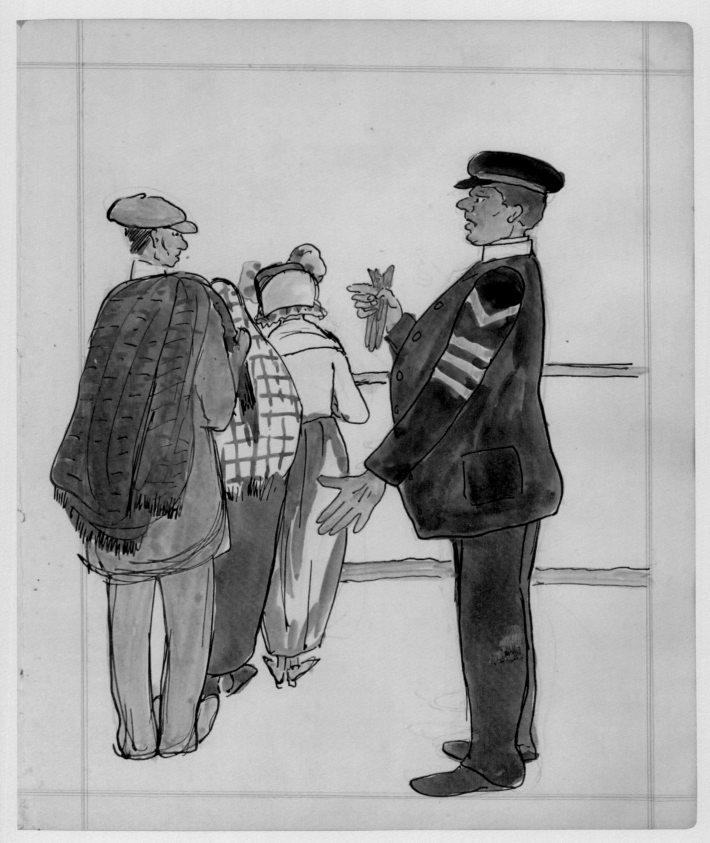

THIS IS A MUSICAL GENII WHO AFFORDED

US MUCH PLEASURE BETWEEN OUR PAROXISMS

OF WOE.

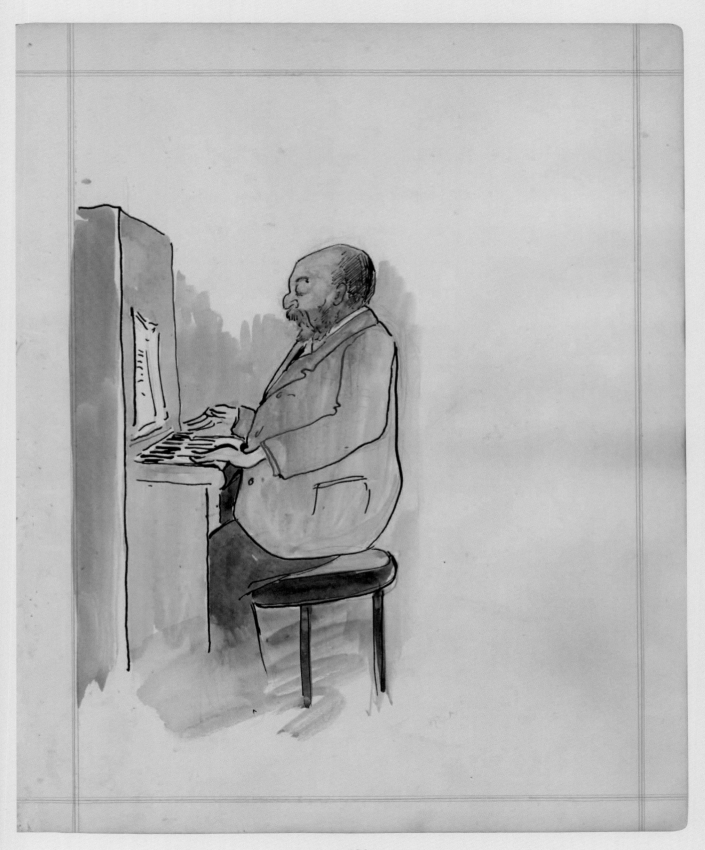

"ROTTON ROW" A BENCH WITH A LURCH AND A
SQUEEK. ON THE DECK CLOSE TO THE SALON DOOR,
TO WHICH THOSE RECOUERING FROM 'MAL DE MER'
ARE CONDUCTED BY THUR FRIENDS AND LEFT TO
REVIFY, THERE ARE USUALLY NO VACIENCIES, SILENCE
PREVAILS PUNCTUATED BY OCCASIONAL GROANS, AND
SEMI-ARTICULATE MALIDICTIONS ON 'MOTHER-SILL'.

" LET THOSE WHO WOULD LAUGH AT THIS MISERY DEPICTED
BEWARE LEST THEMSELVES ONE DAY BE AFFLICTED."

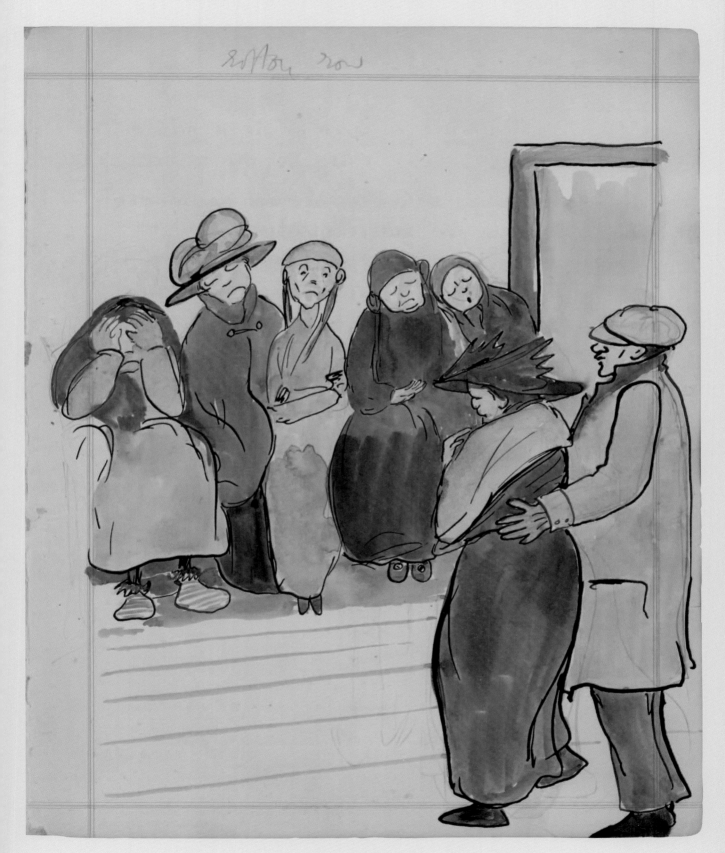

LIVERPOOL AUG 19.

 AND SO WE CAME TO LIVERPOOL, AND ONCE ON
'TERRA FIRMA' AGAIN THE HORRORS OF THE DEEP
AND THE FAILINGS OF 'MOTHER-SILL" ARE SOON FORGOT,
AND OUR MINDS ARE ENTIRELY ABSORBED IN THE
INVISTIGATION OF THE LOST LUGGAGE PROBLEM, THE
OFFICIALS OF THE C.P.R. URGED US TO TAKE THE
EXPRESS TRAIN TO LONDON, AND LEAVE THE MATTER IN
THEIR HANDS TO INVESTIGATE AT LEASURE BUT HAVING
THE UTMOST CONTEMPT FOR THEIR HANDS AND THEIR
LEISURE: WE REFUSED TO LEAVE THE STATION TILL IT
WAS FOUND, WHEREAT SEEING DETERMINATION WRIT IN
OUR FOUR EYES, THEY GOT BUISY THEY DROVE ME AROUND
LIVERPOOL, TO MUSTY UNDERGROUND CELLARS AND VAULTS;
WHERE PILES OF FORLORN, LOST TRUNKS WERE HID AWAY, SISTER
SAT UPON OUR HAND LUGGAGE IN THE STATION MEANWILE: AFTER
VAST INTRICATE MANOUVERING, AND DOMINEERING PERSISTANCY ON
MY PART, WE FOUND IT. AND SWELLED WITH JOY, WE TOOK A
TRIP INTO THE CITY, HERE WE COMFORTABLY LUNCHED, AND
FINDING THE BIRD SHOP QUARTER, I PURCHASED AN
AFRICAN GREY PARROT, (A LONG COVETED POSESSION ON MY
PART) WHICH GREATLY TICKLED ME; SISTER WAS NOT
OVERJOYED AT THE EXTENSION OF OUR FAMILY CIRCLE,
BUT WAS SO ELATED AT GETTING HER TRUNK AGAIN,
SHE WOULD HAVE SANCTIONED MY BUYING A GIRAFFE,
WE CHRISTNED THE BIRD REBECCA. AND ARRIVED THAT
NIGHT IN THE WORLD'S METROPOLIS: PAST TRIALS FORGOT,
AND READY TO TACKLE THE FUTURE ONES:

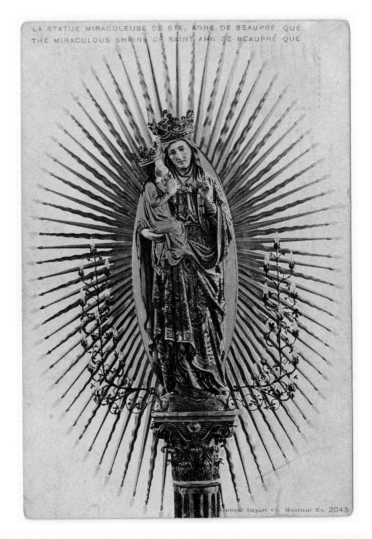

LA STATUE MIRACULEUSE DE STE. ANNE DE BEAUPRÉ, QUE.
THE MIRACULOUS SHRINE OF SAINT ANN DE BEAUPRÉ QUE.

Montreal Import Co. Montreal No. 2043

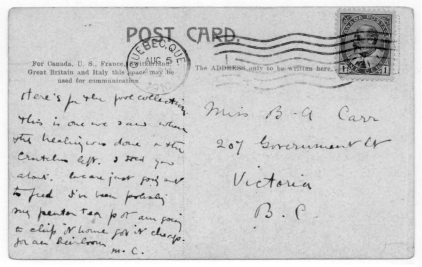

41 — Environs de PLESTIN-LES-GRÈVES (Côtes-du-Nord). Saint-Efflam, la Chapelle. ND Phot.

COSTUMES BRETONS
334. Une Coquette de Pont-l'Abbé

1 — SAINT-MICHEL-EN-GRÈVE (Côtes-du-Nord). L'Église et le Calvaire. ND Phot.

More postcards from France.

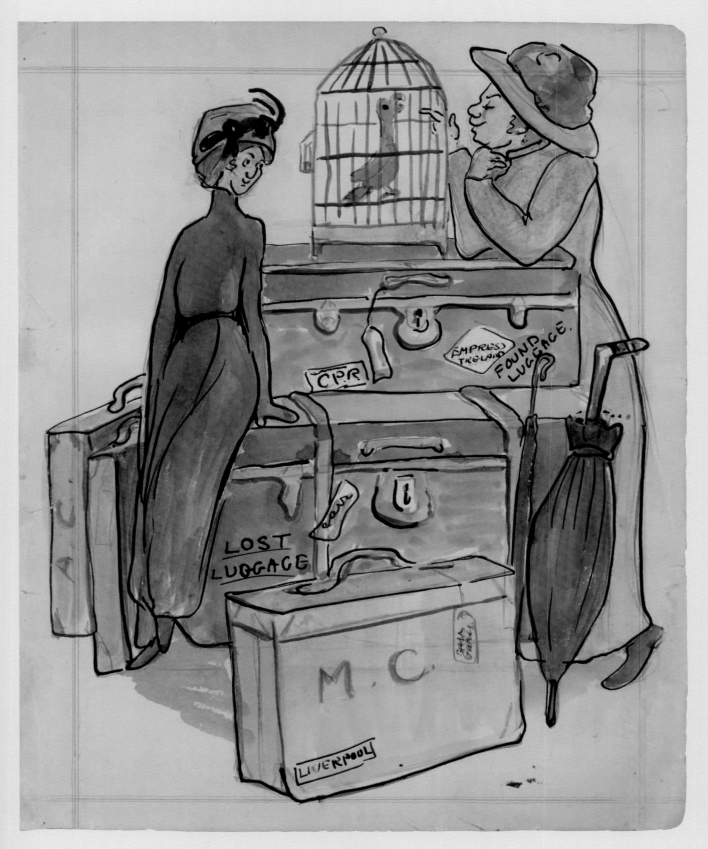

Glossary

Emily Carr misspelled many words in this book, some intentionally. This list contains misspelled words that may be difficult to understand, even in context. It also contains words no longer in common usage and place names that may not be widely recognized.

page 16
BEDWED – bedewed: sprinkled with tears.

page 18
SICAMOUS – A town on the eastern shore of Shuswap Lake, British Columbia. The sisters stayed at the CPR's Tudor style, Sicamous Hotel.
POCKET SHURE – pocket sure: a small, flat traveller's bag worn under the clothing to keep valuables hidden from pickpockets.

page 20
ATTAIR – attire.

page 22
SURLEY – surly.
MINUTUS – minutes.
NO WISE – no way(s).

page 24
GLACIER HOUSE – In 1886 the Canadian Pacific Railway built the Glacier House hotel as a stopover in Rogers Pass. Named for its location in Glacier National Park, Canada's first national park, the small hotel became a destination for hikers, mountaineers and adventurers like the Carr sisters.

page 28
LAKE LOUISE – A stunning emerald-green lake set in the Rocky Mountains in Banff National Park, Alberta. The Carr sisters undoubtedly stayed overnight at the Chateau Lake Louise, a hotel built by the Canadian Pacific Railway in 1890.
BAFLED – baffled.

page 30
WHERAT – whereat: at which point or time.

page 34
BANFF – Today a small tourist town in Banff National Park, Alberta, it was known in 1910 primarily for its hot springs.
SOVOURS – savours: suggests a quality.

page 36
TALLYHOEING – taking a ride in a tallyho, a horse-drawn buggy for sightseeing tourists.

page 38
'BRAMER LODGE' – Calgary's Braemar Lodge was renovated in 1904 from a private house to become a fashionable hotel.
CARCAS – carcass.

page 40
MORTIFING – mortifying.

page 48
MEDICINE HAT – A town on the South Saskatchewan River in southeastern Alberta, known for the natural gas fields surrounding it. Gas as an energy source was new to the sisters.
WHERE WITH – with which.
EXCRESSENCE – excrescence: a bulge; or literally, an ugly wart-like outgrowth, which is probably the impression Carr intended to give.
PO-POOED – pooh-poohed.
BARLEY WHERE – barely were.

page 50
SHEWN – shown.

page 52
O'USE – 'ouse: house with the "h" dropped to give the impression an East London accent. This also applies to "ALLAS SCOWERS" (always scour) and "'ERE'S A 'HUNCLEANED' ROOM YE CAN 'AVE."

page 56

BROADVEIW – Broadview: a small town in Saskatchewan about 155 kilometres east of Regina.

DANAGE – damage.

page 62

OMNIBUS – bus.

ON OUR CHESTS – on our minds.

CEASED – the "D" is on the facing page.

page 64

PULMAN – Pullman: a sleeping car on a train.

DESPAIRING – the "ING" is on the facing page.

INTELLIGENCE – the "E" is on the facing page.

CLOE – clothes, abbreviated to rhyme with "WOE". It may have been inspired by Carr's friend, Sophie Frank. In *Klee Wyck*, Carr quotes Sophie requesting "Old clo', waum skirt" in exchange for a basket she'd woven.

page 68

CONVEVED – conveyed.

page 70

INTERPRITATED – interpreted.

page 74

APPALATION – appellation: a name or title.

GRAND PARAPLUIE – large umbrella, in French.

GAMP – a large unwieldy umbrella, named after Sarah Gamp, a character in the Charles Dickens novel *Martin Chizzlewit*.

page 80

DISHONOURABLE – the "E" is on the facing page.

page 81 and 86

JOB JEWIE / JOB JEWY – Carr's fictional name for the antique shop and the shop keeper who sold her a silver-plated tea set claiming it to be antique pewter. Such ethnic slurs were not uncommon in Carr's time.

page 90

SHRINE OF ST ANNE DE BEAUPREY – Quebec City's Basilica of Sainte-Anne-de-Beaupré is a Catholic pilgrimage site whose devotees claim has miraculous curing powers (see also the postcard on page 111). The sisters arrived in the city just a week or so after the feast of Saint Anne, the patron saint of Quebec.

page 92

LE GUARDIEN ANGE – L'Ange Gardien, then a small community north of Quebec City that the sisters reached by rail.

page 94

CHARISTERISTICS – characteristics.

TORTORSHELL – tortoiseshell. A tortoiseshell cat has orange and black fur.

page 96

SPECTLE – spectacle.

EATON JACKET – Eton jacket: a waist-length jacket with an open front, named for the style worn by pupils at Eton College, England.

page 98

MAL DE MER – seasickness, in French.

MOTHER SILL – Mother Sill's Seasick Remedy was an anti-nausea compound dating back to the early years of the 20th century. In 1912 the *Journal of the American Medical Association* included it in an article about quack remedies. Still, the product stayed on the market for decades.

page 100

SPY-CATTING – possibly spying in a sneaky fashion, like a cat.

page 102

GENII – genius, mistakenly plural.

page 104

ROTTEN ROW – A place in Hyde Park where it was fashionable for upper-class Londoners to be seen, especially on horseback. Carr probably used it ironically.

REVIFY – revivify: restore to activity.

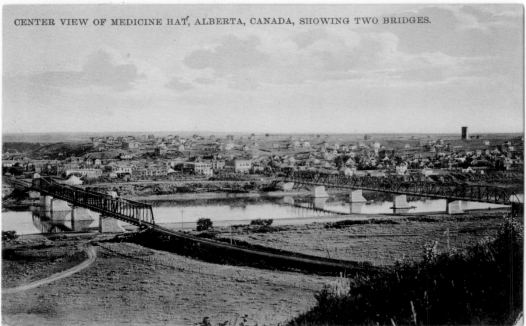

Above: Two postcards from Alberta.

Facing page: The Miraculous Shrine of Saint Anne de Beaupré, Quebec City, that Carr describes and illustrates on pages 90–91. On the back of the card, Emily tells her sister, Elizabeth, about the shrine and about the beautiful pewter tea set that she and Alice are preparing to send home, as descibed on pages 82–89.